DESIGNING
A PHOTOGRAPH

R E V I S E D E D I T I O N

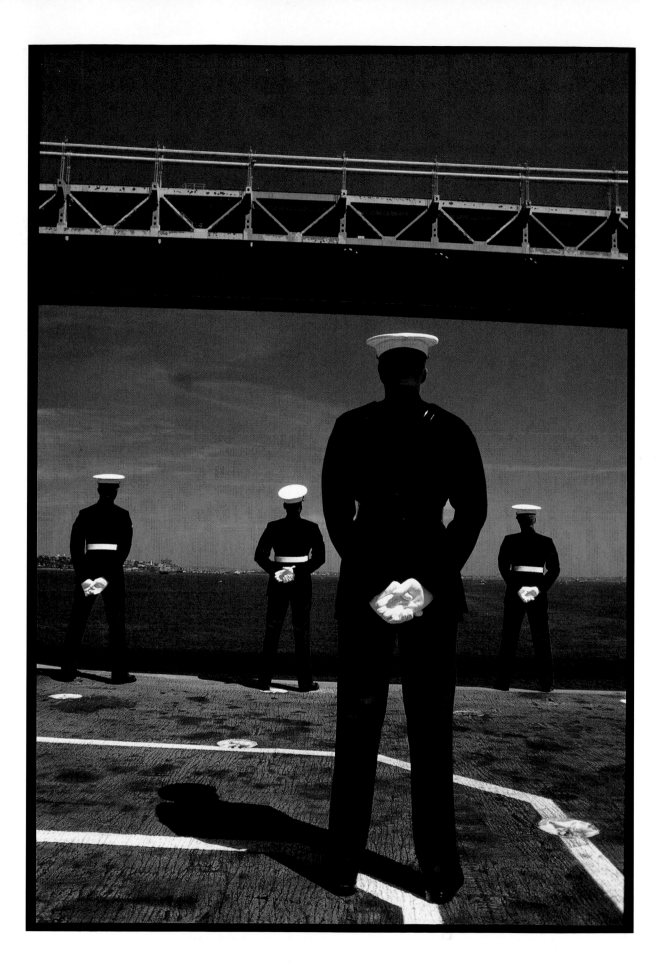

DESIGNING A PHOTOGRAPH

REVISED EDITION

VISUAL TECHNIQUES FOR MAKING YOUR PHOTOGRAPHS WORK

Bill Smith

AMPHOTO BOOKS
AN IMPRINT OF WATSON-GUPTILL PUBLICATIONS/NEW YORK

My thanks to the following companies whose technical expertise, high standards, and excellent service over the years helped make this book possible.

Eastman Kodak
Rochester, NY

Hall Color
515 Bath Ave.
Long Branch, NJ

First published in 2001 by AMPHOTO Books, an imprint of Watson-Guptill Publications, a division of BPI Communications, Inc., 770 Broadway, New York, NY 10003. www.watsonguptill.com

Library of Congress Cataloging in Publication Data
 Smith, Bill, 1952-
 Designing a photograph.
 Includes index.
 1. Composition (Photography) 2. Photography, Artistic.
 I. Title
 TR179.S64 2001 00-65009
 ISBN: 0-8174-3778-9

Printed in Malaysia

1 2 3 4 5 6 7 8 / 08 07 06 05 04 03 02 01

Senior Editor: Victoria Craven
Editor: Jacqueline Ching
Designed by Jay Anning, Thumb Print
Production Manager: Ellen Greene

I dedicate this book to my wife Amie who has believed in me always
and is still my best friend. Thank you for the years that we have been
together and I am glad that I have entertained and amused you.

CONTENTS

INTRODUCTION

While almost every family in America owns a camera, few people are good photographers. The process of taking a picture is so simple a child can do it, but a special vision is necessary to see a subject with total clarity and sum it up in 1/500 of a second. Although the image can be altered after it is on film, the amount of the alteration is limited by the process (color or black-and-white) and the image is final. The ability to see with a complete vision is what separates a photographer from the casual camera user.

A camera is used to capture a moment, a feeling, to record for posterity, and to satisfy your ego. Yet, it must also be used with certain objectivity. A photographer can be carried away by emotion, which can lead to carelessness. For example, you might inadvertently leave litter, cars, and telephone wires in a scenic shot, greatly minimizing its splendor. The camera is a tool that is only as good as the eye that applies it.

By placing a camera between you and your subject, you change the experience radically. The photographer becomes an observer, no longer a participant. When he or she attempts to be as much a participant as an observer, the image suffers. The responsibility of the photographer is to sense, feel, and capture on film the beauty and the emotion, while being detached enough to view it in its entirety.

To create well-designed images, the photographer needs to know how the mind sees and organizes information. You see with your mind. Your eyes are merely lenses like the ones you have on your camera. A basic understanding of how the mind works allows the photographer to design an image that communicates the desired message. In "Mind and Eye," the concepts underlying clear visual communication are explained. The focus then turns to different techniques that can be used to expand how you look at the world with a camera. "Look Before You See" offers techniques and exercises, with possible visual solutions. The exercises provide a way to sharpen your visual skills and visual awareness.

> *By placing a camera between you and your subject, you change the experience radically. The photographer becomes an observer, no longer a participant.*

The chapter "Film and Light" examines both black-and-white and color film, and how they react and render a final image under various lighting situations. Since all photographers, amateur and professional alike, shoot under different lighting situations it is necessary to see and understand how the film will react and how to use both to create strong visual imagery.

Photography is a process that has an evolution, a direction, and self-imposed boundaries. In "Where Is Your Work Going?" the focus is on the questions that a photographer inevitably must address about his or her own work. Over the years your photographs will change as you change. The key is to see these changes and understand where you have been and where you are going.

A good sense of design is necessary and is applicable to anything that you photograph. In "Applied Design," problem solving and visual solutions help to achieve the best possible shots from such subject matter as sports events, nature, travel, and advertising. The practical application of the computer in terms of retouching and design is covered as well.

Since a photograph is used for visual communication, it must have strength and clarity. To help the viewer see what is intended, the photographer incorporates a sense of design to direct the movement of the eye within the frame. This motion must be continuous and smooth, because the person who looks at a photograph wants to see it easily and not have his eye pushed or pulled around the frame.

A well-designed image is one in which information has been either selectively included or deleted. What is included must be organized in a manner that maintains the viewer's interest. It is the photographer's responsibility to make images that are clear and uncluttered. Photographs with coherent designs allow motion to be maintained.

There is one vital element that you add to a photograph that no one else can. Your vision is unique and it influences every shot you take. Is there really anything that you will shoot that has never been photographed before? Only the

35mm camera, 100mm lens, Kodachrome PKR64

way you see it will make it look different. The same statement holds true for the contents of this book: It does not cover new information. The information has already been taught in countless classrooms and has been written about in numerous books. But it does differ in the way that concepts of design and solutions to visual problems are presented. In photography, or any other creative endeavor, only the presentation changes, not the basic form.

As necessary as definitions, categories, and judgments are in our world, they can complicate the work of a photographer. The judgment of whether work is great or a failure is the realm and responsibility of others. It is a function of time and timing relative to the work of others. People are far more comfortable when everything is defined. The definitions of what is art or commercial, of what is scenic or abstract, are necessary to others, not to the photographer. The photographer should accept categories only for what they are and not let them determine what images to create. Like definition, praise is good and necessary, but it should be accepted for what it is, no more or less. This is a difficult task for any person to accept, but for the creative person it is a necessity for growth and exploration.

Not every photograph in this book is equal in strength or interest. But each serves the specific purpose of illustrating concepts, offering solutions to problems, and suggesting ways to work within certain boundaries. Whether or not you like a particular image is irrelevant. What matters is your understanding of the point that it illustrates. The one constant, in all of the images, is that they all show a sound sense of design.

This book offers the potential for you to create photographs closer to what you intend. Unfortunately, it cannot make you a great photographer. Only by continuous work and a passion for the process can this be possible. A great photographer is only someone who is more consistently good than others in the profession. A passion for photography, coupled with an endless curiosity to see what more can be created, is a characteristic of a great photographer. It does not mean you will not reach this level. It only means that it has to come from you. No book or class can do it for you. But this book is valuable in that it offers a way to create images with a stronger sense of design. That is a very important piece of knowledge to have at your disposal.

MIND
AND EYE

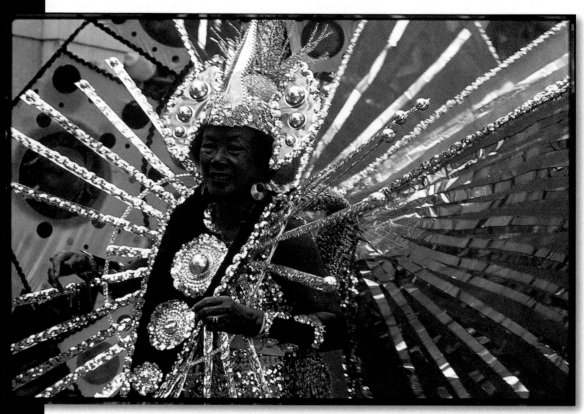

35mm camera, 100mm lens, Kodachrome PKR64

CONCEPTS FOR CLEAR
VISUAL COMMUNICATION

*The whole is different
from the sum of the parts.*

TELEVISION, MOVIES, AND PHOTOGRAPHY ARE ALL FORMS OF VISUAL COMMUNICATION. ONLY photography relies on a single, unmoving image without benefit of sound and motion to reach the viewer. The first thing a photograph must have is the strength to draw the viewer's attention. Then its parts and subtleties must work to maintain the viewer's interest or curiosity. A Japanese proverb applies to the effect of a good image:

You see the simple beauty of the pond's surface. As you look more closely, you see the endless worlds within worlds beneath its surface.

Remember a photograph is a two-dimensional plane that is compressed from a real and tangible three-dimensional scene. A photograph has no physical depth, and details are omitted as the scene is compressed onto film. As a result, the information in the scene is selectively organized and affected by choice of lens, perspective, and cropping within the frame. A photograph is a selective representation of reality, and it freezes the scene and the moment in time. It is an illusion, a visual communication of reality subjectively seen.

> *A photograph is a selective representation of reality, and it freezes the scene and the moment in time.*

Ideally, a photograph does not need an explanation. If the photograph is weak, words will not make it stronger. The photograph must communicate in a simple coherent way and not rely on words to explain, describe, or defend its message and purpose. A good photograph relies on the organization of all the elements in the scene to create clear communication. Your vision and design affect how the image will be seen.

Although it may appear obvious, an awareness of the frame of an image is extremely important. Since the frame's edges are the boundaries by which the image is defined and limited, the photographer must be aware of all the elements within, their placement, and their effect as a total unit. As a result, an excellent habit to acquire, and then continually integrate, is to scan the edges of the frame before clicking the shutter. Elements of brighter tonality can pull the eye out of the frame rather than continue visual movement. The attention given to the edges may be cut short by the need for a quick response to the scene, but the photographer must always be aware of the frame. Regardless of how much time you have, it is as necessary a step in the process as checking exposure or focus.

How and what you see is the sum of all your knowledge, experience, and memories. You bring all of this to each photograph that you shoot or see. Your eye is only a lens; it has no memory, knowledge, or experience. When you see the back of a hand, you know because of your experience there is another side to it, even though it is not visible. A baby sees only one side because no experience has informed the infant that there is more than what is actually seen. Understanding how the mind organizes information during the process of seeing is invaluable. This process provides the photographer with the knowledge to design an image that facilitates clear communication and motion within the frame.

The study of the process of seeing is called visual perception, an area studied by psychologists for many decades. In this chapter, the basic concepts used to describe the process of how information is organized are taken from gestalt psychology. This is only one facet of visual perception, but it is this process that allows the picture to be seen as a single whole image. Each part of a photograph is actually seen separately. The mind's ability to group them all together allows them to be seen as one image. As gestalt psychology states: "The whole is different from the sum of its parts."

The words "visual element" refer to anything seen as a discrete recognizable unit. This can be a person, a number, a french fry, or a horse. Visual elements vary in size, shape, color, and texture. They can be similar or dissimilar.

The photographer has a variety of tools with which to alter the design of an image. Your selection of film, filtration, lens, focus, lighting, and format depends on the way you choose the picture to be seen.

SELECTIVE FOCUS
USE FOCUS TO DEFINE A SUBJECT

Selective focus, in which you intentionally throw certain elements out of focus, is a tool that can be used to define the importance of your subject. Keeping the background out of focus will isolate your subject, since the eye will not remain in an area that is out of focus. Both the background and its relationship to the subject will be seen, but the eye will quickly return to the focused area. Even though part of the photograph is out of focus, the shapes, colors, textures, and light-to-dark relationships of the foreground and background must complement and enhance the subject. Although selective focus affects visual motion and defines importance, it is still necessary to maintain an awareness of how the subject relates to the entire frame.

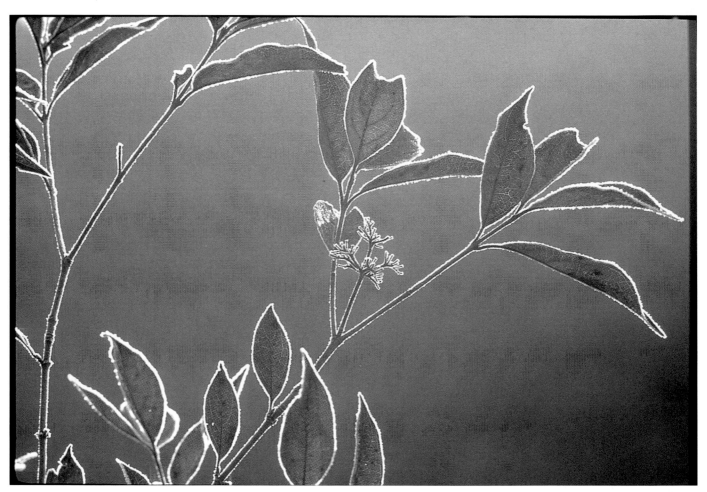

100mm macro lens, Kodachrome PKR64

This shot of frost on the leaves and branches is a very clear example of selective focus. Sunlight coming from slightly behind the subject highlights the frost and allows the texture of the leaves to be seen more clearly. The background, which is completely out of focus, is only defined by changes in tone. As a result, your eye may travel to the background, but it returns to the branches and leaves.

Keeping the background out of focus will isolate your subject . . .

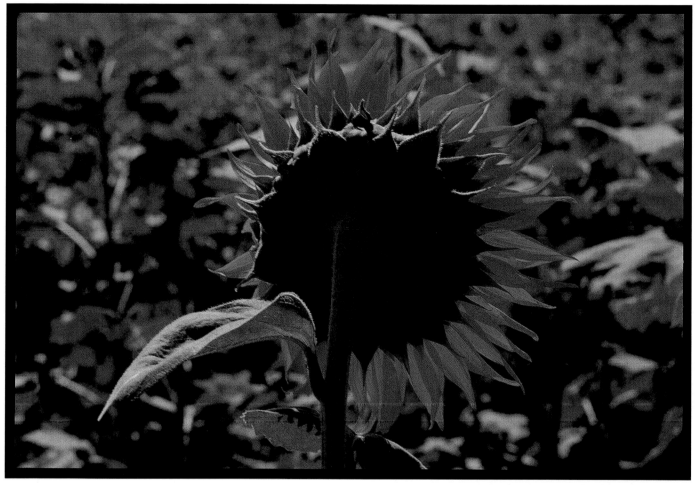

100mm lens Kodachrome PKR64

To avoid an obvious or predictable result, take the time to look at a subject in a novel way. The use of selective focus is more problematic in this image because the elements in the background are more clearly defined. When elements are identifiable yet out-of-focus, special attention has to be given to how the background and subject complement each other. Here the out of focus sunflowers and leaves in the background bring your eye back to the sunflower, which is in focus. No matter what your subject is—whether a portrait, sports, or nature—you need to be aware of how the background will look when using selective focus.

A wide aperture (f/1.4–f/4) gives you a shallower depth of field. In other words, it gives you a narrower zone of sharpness. In the design of a shot, figure out whether important elements will be sharp.

13

LENS SELECTION
VARY THE FOCAL LENGTH

The lens you choose when you take a photograph is as important as any other tool available. A long lens (telephoto) will compress and increase the size of the image. A wide-angle lens will increase and exaggerate the feeling of depth and scale. The choice you make is critical since it affects how the image is perceived. However, the use of special lenses, such as a fisheye lens or a 500mm lens, will not make up for a boring subject or a bad sense of design.

Commercially, the choice of lens is generally determined by subject, use of the photograph, the effect that is required for the job, and the physical space limitations. Most photographers favor certain lenses over others, in both professional and personal use. For commercial work, I use every lens that I own over the course of a year. The shot determines my choice of lens. When shooting for myself, I use a 28mm as a normal lens and my other favorites, a 20mm and 100mm macro. Lenses with a focal length of 42mm to 55mm (in 35mm format) are called normal lenses because they approximate the human eye's angle of view. But I prefer a 28mm lens because it comes closest to showing how I see the world. The 100mm macro is excellent for portraits and close-ups, while the 20mm lens is excellent for landscapes and other scenics.

Before you begin to favor one lens over another, you must first learn and test the limitations and capabilities of each lens. Knowing your lenses gives you further control of the design of your photos, and how well they communicate.

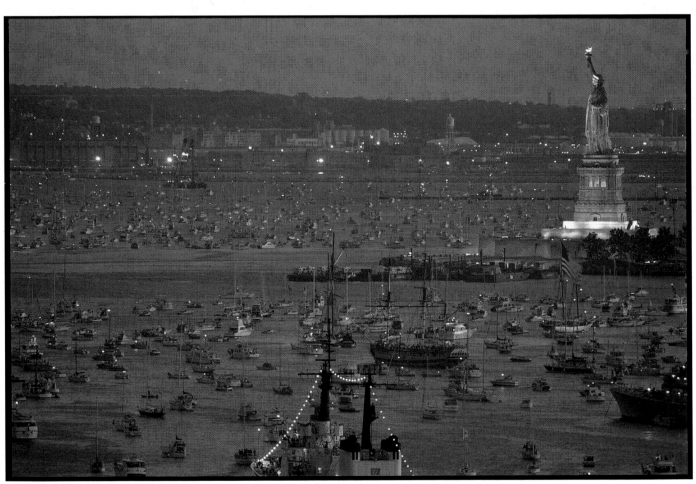

35mm camera, 400mm lens Kodachrome PKR64

As you look at this photograph, shot for the U.S. Navy for the Liberty Centennial, the effect of perspective and lens selection is immediately clear. This overall shot gives the viewer a feeling for the scale and grandeur of the event by enlarging it. The long lens compresses the scene and enhances the perception of the harbor being filled with boats. Simply, lens choice has defined how the subject has been perceived. Because of the distance, the only way to shoot this image was with a very long lens.

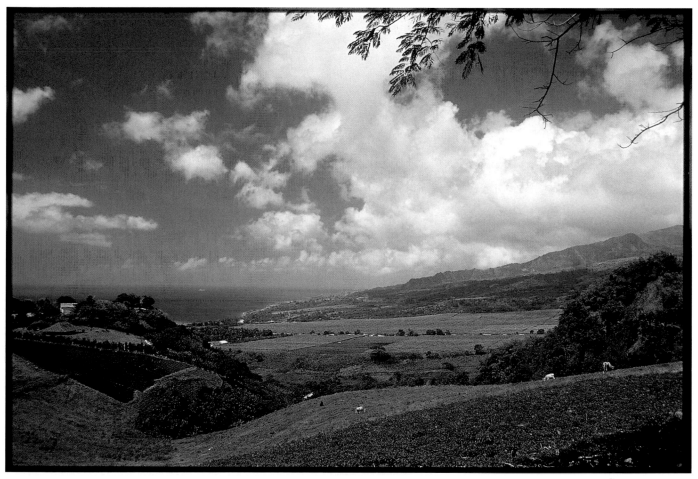

35mm camera, 24mm lens, Kodachrome PKR64

Martinique is a beautiful island with many stunning vistas. The use of a wide-angle lens allowed me to frame the scene with both the branches and the shadow of the tree to show the scale, beauty, and depth of the landscape. Usually landscape and scenics are photographed using a wide lens. Look at both of these shots and compare how they render a scene.

The focal length number refers to the magnifying power of a lens. Longer focal lengths, like the 100mm lens, make the subject bigger and narrow the field of vision. Shorter focal lengths, like the 20mm lens, give a broader field of vision, making the subject smaller.

. . . learn and test the capabilities of each lens.

FILTERS
CONTROL LIGHT AND COLOR

Filters are useful for controlling light and color. Yet of all the tools available to a photographer, they are probably the most misunderstood and misused. For the amateur, the two most commonly used ones are the UV filter and polarizing filter. Frankly, the only good reason to use a UV filter is to protect the lenses from damage, such as scratches. It is cheaper to replace the filter than the lens. The polarizing filter is only effective when the photographer is pointing the camera at a 45- to135-degree angle to the sun. It is used to darken a sky, reduce glare, or remove reflections. There are many other filters available for professional use. They are not useful for amateurs, except for filters designed for black-and-white film. The most useful filters for black-and-white photography are red, orange, green, and blue. Red and orange add contrast to darken a sky, while green and blue brighten their respective colors in the final print.

For the professional photographer, filters, specifically color gelatin filters, are used frequently for color correction. On location where light sources and color temperature vary, color-correction filters (cc filters) are necessary to render a scene realistically. Working with a color meter, a photographer can use filters to change the overall color of the final image. The meter, coupled with the use of a Polaroid camera, is just a guide for the photographer, who relies on experience to interpret the needs of the situation. Proficiency with cc filters requires experimentation and patience.

These two shots offer a creative way to use filters. On location for a client, DECO, I had to shoot a very small airport and make it look dramatic. The shot on the near right shows the color of the light as it really was. Gelatin filters gave the shot on the right a sunset feel. This was the shot that was delivered to the client.

Working with a color meter, a photographer can use filters to change the overall color of the final image.

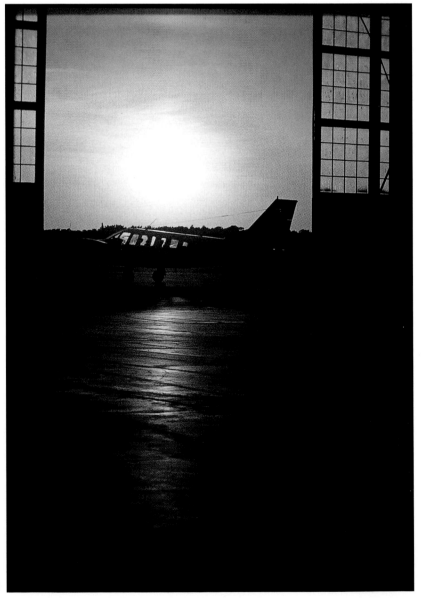

35mm camera, 200mm lens, Kodachrome PKR64

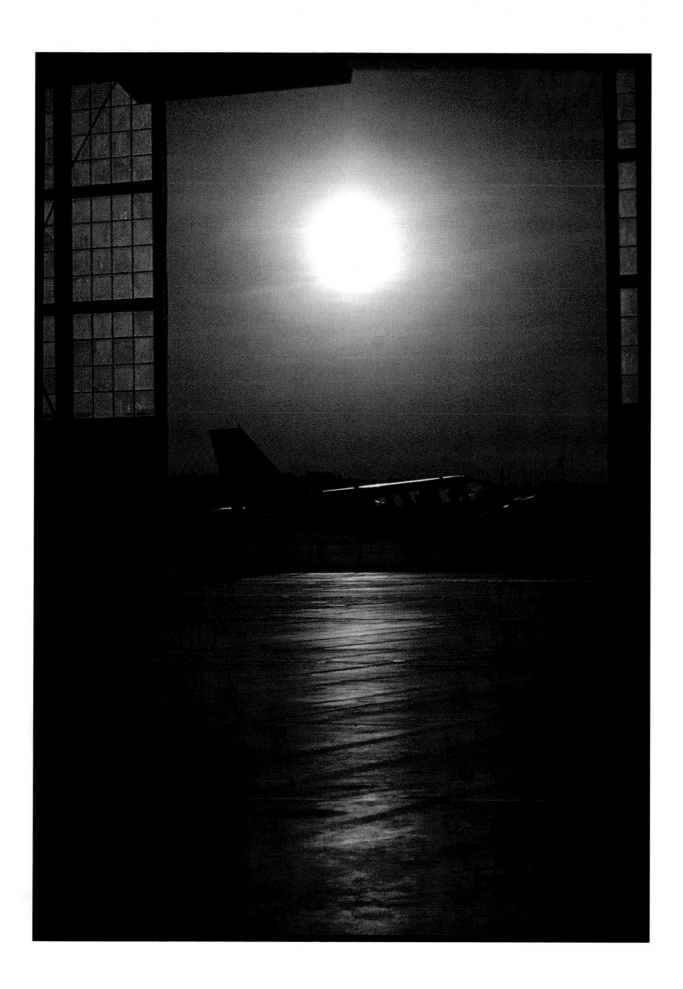

FIGURE/GROUND
DEFINE THE ELEMENTS OF DESIGN

Different disciplines employ different words to describe the same thing. In art, positive and negative space describe the same relationship that psychologists define by *figure* (subject) and *ground* (background). The words have changed but not the relationship.

It is impossible to have a subject without a background. The function of the background is to define the subject by giving it a context in which to exist. To a degree, the need for context is why people hallucinate in the desert. Everything begins to look the same; nothing is defined, so the mind creates a figure. Since the background defines the figure, awareness of the interaction of these two areas is necessary when you take a photograph.

The selection of figure and ground continually occurs in our daily lives and involves all of the senses. For example, you are at a party. The noises include a radio playing in the background and various conversations. At this moment, your conversation is figure; the other noises are ground. Suddenly, one of your favorite songs begins playing on the radio. Now, the radio is figure and the conversations become ground.

When you walk into a restaurant, you are suddenly presented with a vast array of smells. Initially, you will attempt to define those smells which are either the least or the most familiar to you. One smell is recognized and becomes figure. You then move onto the next smell and the first one becomes ground. Again the selection of figure is subjective and continuously changing.

The same process exists for the sense of touch. When you buy a camera, aside from the technical wizardry, you change from one model to the next, searching for the one that feels best in your hand. Weight and size are figure, while gadgetry is ground.

When you are having dinner, whatever is familiar or new and unknown to your taste buds becomes the focus of your attention. You don't just taste one thing. There is a continual changing of figure and ground.

The process of figure and ground selection varies from person to person. Have you ever overheard a group of tourists reacting to their surroundings? One sees the architecture; another wants something sweet and goes to a candy store; a third wants to write home about the tour and goes to a postcard vendor. Each individual's perceptions are different.

The photographer must constantly be aware of both figure and ground. By selection and deletion of information in the frame, a photographer controls an image and how it is seen. The background is as important as the subject. As you take photographs, first look at the subject and then the background. They are separate, yet the way they work together is critical to the success of the image.

Here separation between figure and ground is clearly defined. The red hat and the shape of the man contrast with the light and, most importantly, the shadows across the floor. A large amount of space surrounds the figure and emphasizes his importance. Visual motion within the frame is created by the shadows and the inclusion of the bottom of the escalator, which brings your eye back to the figure. The figure has shape, form, and contour. It is smaller than the background and appears closer to the viewer.

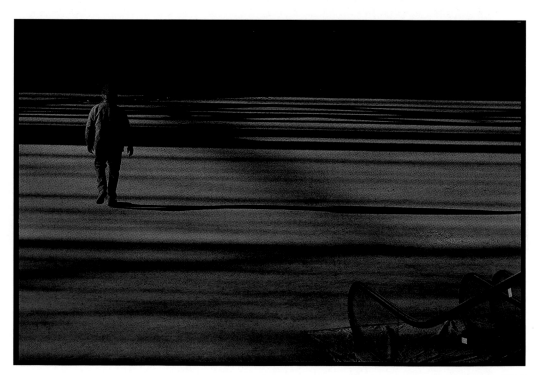

35mm camera, 100mm lens, Kodachrome PKR64

The following statements define the role and relationship that exists between figure and ground in a photograph.

- Regardless of its placement in the frame, figure is perceived as being closer to the viewer. The more the background recedes because of lack of focus, the closer the figure appears.

- Figure usually occupies a smaller amount of space in the frame than ground. Although it may appear larger and closer because of focus and importance, it usually takes up less physical space than ground.

- Figure and ground cannot be seen simultaneously, only sequentially. When you read while you watch TV, are you really seeing both at the same time? Your attention continually shifts from one to the other. You can't see both simultaneously.

- Figure is seen as having form, contour, or shape, while ground is not seen as having these characteristics.

By selection and deletion of information in the frame, a photographer controls an image and how it is seen.

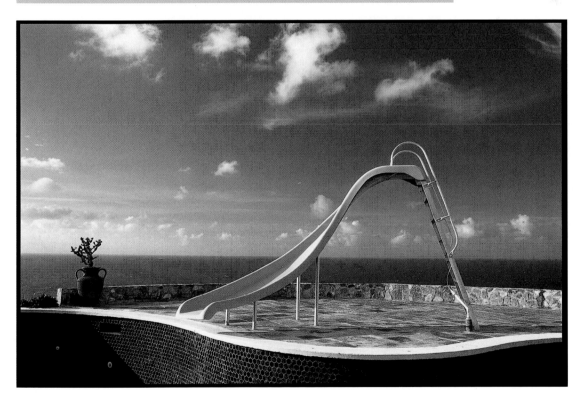

35mm camera,
28mm lens,
Kodachrome PKR64

While looking for a vantage point to shoot cruise ships, I came upon this scene in St. Martin. The curving shape of the pool slide is perceived as the figure and enhanced by the background. The blue of the sky, water, and tiles complements the blue in the slide. The curve of the pool edge, terrace, and pots repeat the curve of the slide. This whole shot has a very gentle, easy visual motion. The integral relationship between figure and ground creates and enhances visual motion within the frame of this photograph.

FIGURE/GROUND FLIP
ENHANCE THE BACK-AND-FORTH MOTION WITHIN AN IMAGE

The process of figure/ground flip occurs in our day-to-day activities. If you do two things at once, like watching television and reading the paper, your eyes shift focus back and forth from one to the other. As the television becomes figure, the paper becomes ground. When you shift your attention to the paper, it is figure, and the television is ground. Both cannot be seen simultaneously, only sequentially.

The relationship between figure and ground can add another dimension to an image. In nature photography, a rock, a branch, or a part of the shoreline is sometimes used as a visual stepping-stone to the mountains in the background. The rock is figure and becomes ground as the eye moves to the mountains. When two people are being photographed together, a stronger, more contrasty light placed on the person standing in the background will create a reversal. In both these examples, the visual motion of a figure/ground flip enhances the relationship between the two areas, making the final image more interesting. The use of this technique is as subjective as the choice of lens, film, or perspective.

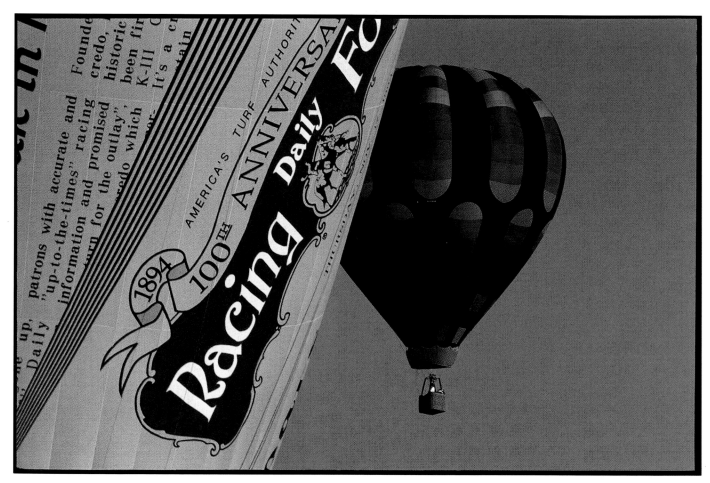

35mm camera, 200mm lens, Kodachrome PKR64

Every year in New Jersey there are two big balloon shows. In this photograph, your eye is first drawn to the red-and-white type and then to the curve of the balloon in the background. It is the proximity/closeness of the foreground balloon to the background balloon that makes your eye move back and forth between them. The curved shape of one balloon is repeated in the other. Note that the balloon in the foreground has the reverse tonality of the one in the background. By cropping the balloon on the left, I have found that many people assume that it was a sign and not a balloon. A figure/ground flip not only creates strong visual motion but, if it is used correctly, it can also make viewers stop and think about what they are seeing.

In photography, a strong visual relationship between figure and ground enhances back-and-forth motion in an image. This is further enhanced by a reversal, or flip, of figure and ground. This can be achieved through the use of strong contrast, lighter tones, more details, intellectual or emotional associations, or stronger shapes placed in ground rather than in the figure.

The relationship between figure and ground can add another dimension to an image.

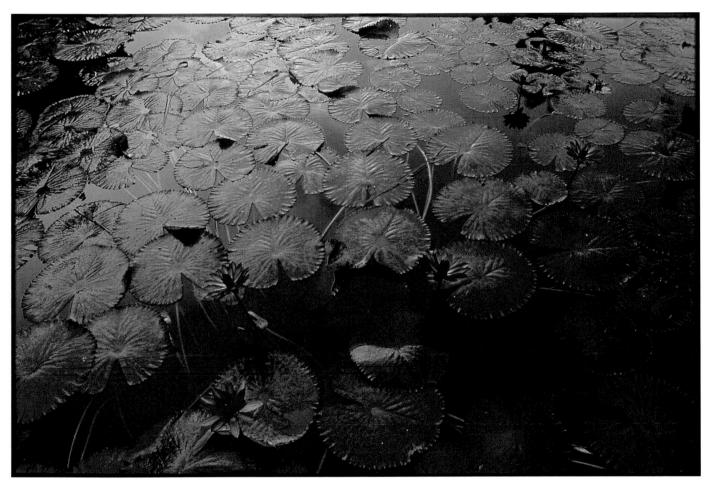

35mm camera, 28mm lens, Kodachrome PKR64

While on location in Barbados I found this scene at a seminary school. This shot of a lily pond is a more complex example of a figure/ground flip. Your eye is first drawn to the warm and vibrant color of the flowers. As your eye follows the flowers to the right rear of the frame, it is the round shape of that flower and its proximity/closeness to the round shape of the lily pad that starts your eye moving again. The round shape of the other pads moves your eye, and as it does, you become more aware of the pattern in the pads themselves. Finally, your eye comes to the curved, submerged stems, and then begins its journey around the frame once again.

PROXIMITY
USE PROXIMITY TO CREATE MOVEMENT

Your best friend of many years is in from out of town and you decide you want a picture for the photo album. As you click the shutter, the scene is compressed onto the two-dimensional plane of the film. A telephone pole located in the background now looks like it is growing out of your friend's head. Because the head and pole are so close (proximity), the mind groups them and sees them as related. Unfortunately, this effect is probably not what you intended. If you paid attention to the background, your friend could have been moved right or left to reduce the proximity of the pole, preventing a viewer from grouping the two together.

Compression of foreground and background increases as the focal length of the lens increases. Therefore, you should pay extra attention to the relationships created between figure and ground as the focal length of the lens increases. You can use proximity to create movement. When two or more visual elements are in proximity, they are grouped and seen as being related or in a pattern. Due to proximity, this visual association creates side-to-side, up-and-down, and front-to-back movements. Because of the range of motion that can be created within the frame, this is a valuable tool that can be used by the photographer to affect how the photograph is seen.

In our day-to-day existence proximity plays a fundamental role in our perceptions. Memory, comparison, learning, and reading are all dependent on good proximity. In fact, as you read this section you will find that good proximity is necessary to reading. When the letters aretooclose together it is not as incomprehensible as when they are spaced t o o f a r a p a r t or at ir regula r in ter vals. Groupings of similar elements in a pattern, such as grouping letters into words, can only be easily seen when they are in good proximity. Phone numbers, charges on a bill, the price of a product, captions for photographs, to name only a few, rely on proximity to create an order that is coherent.

Any form of comparison is enhanced by having the elements close enough together to form a conclusion. A man who is seven feet tall appears large when he stands in a crowd. In a field of wheat, with nothing nearby to compare him against (poor proximity) he does not seem unusually large. It's easier to judge the quality of a product when two or more are compared side by side. You buy one apple over the others because it looks better in comparison.

To judge the quality of your photographs when printing, it is necessary to place them side by side. Good proximity lets you see what to alter in the next print. Placing them together creates a frame of reference, making comparison easier and judgment more accurate.

Our memory is triggered by proximity. In memory, grouping is determined by temporal not spatial relationships. For example, when you misplace your car key or wallet, you retrace your steps for clues to where you might have left them. Movement during that time period is grouped together, so that you can remember where you were since you last saw the object.

For you to follow the story and sequence of scenes in a movie or a television show, good proximity of elements in time and space is necessary. A logical sequence is necessary for the viewer to understand the story. If there is no continuity between the sequences, they will be seen as fragments, not as a whole story.

In our perceptions in our day-to-day existence proximity plays a fundamental role. Memory, comparison, learning, and reading are all dependent on good proximity.

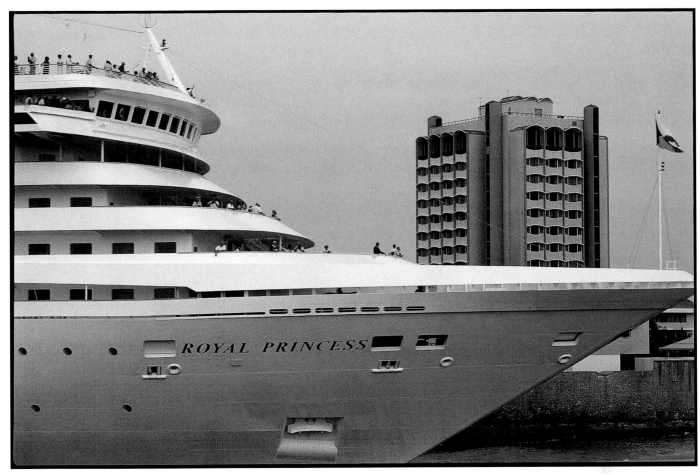

In Curaçao, the sound of a horn signaled that a cruise ship was preparing to depart. The use of a long lens has increased the compression from front to back, so this cruise ship appears to be touching the shore. Proximity of the two elements groups them together and results in visual motion from side to side and front to back. Other elements, such as similarity of shape, also create visual motion. The shapes of the windows in the high-rise are repeated in the ship, and the triangle of the wires and bow of the ship brings your eye to the flag pole and triangle of color. Your eye groups similar shapes, creating movement around the frame.

SIMILAR SHAPE
GROUP ELEMENTS BY SHAPE

You decide to spend the day at the beach. You look at the people, birds, and boats that are on the beach and in the water. Unconsciously, you divide these subjects into groups, according to shape. The beautiful body of a woman catches your eye as she walks along the shore. Your eye then scans the beach for other women. As your eye roams the scene, you see a woman accompanied by a fat man. Your eye proceeds to search for other people with a similar shape. Then, you see the boats as a group, and you divide them according to different shapes.

You "read" a photograph in the same way. Your eye groups shapes that are similar, and this creates motion. This organization by similar shape is a continuous part of our daily lives.

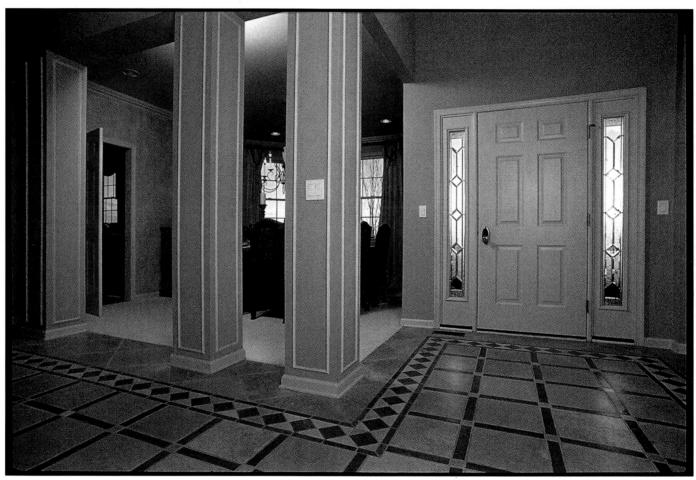

35mm camera, 20mm lens, Kodachrome PKR64

My client, Porcelanosa Tile, wanted to shoot its product to show how its customers used it. The key was to show not only how it looked in use but its texture as well. To achieve this, I grouped visual elements by similar shape to create visual motion within the frame. The square in the floor is repeated in the door and windows. The long rectangles of the pillars and doors are repeated in the floor. The diamond shape seen in the floor is repeated in the glass in the door. Grouping by similar shape facilitates eye movement throughout the frame.

Your eye groups shapes that are similar, and this creates motion. This organization by similar shape is a continuous part of our daily lives.

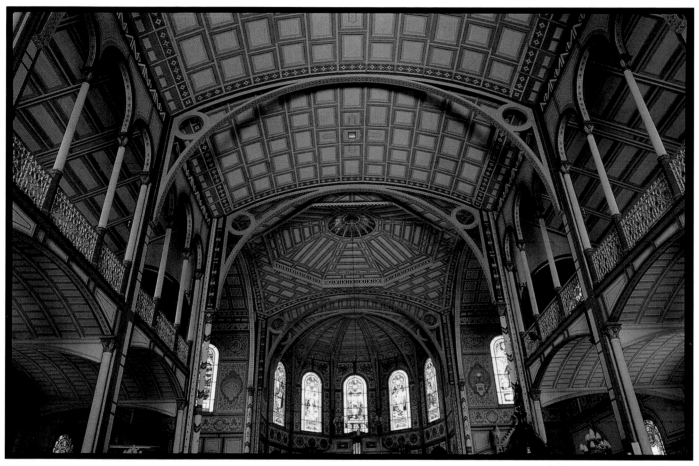

35mm camera, 24mm lens, Kodachrome PKR64

There are a number of beautiful churches throughout the Caribbean. This one, shot in Martinique, has a lot of detail in the interior. This shot relies on the grouping of elements according to similar shape to create visual motion. From the curves found in the archways, ceiling, and windows to the circles found in the ceiling and walls, similar shapes are repeated. Shapes of columns, rectangles, and squares are also repeated throughout the frame. Yet the triangles that are part of the design of the arches create the most motion because they are fewer and smaller in size.

SIMILARITY AND PROXIMITY
GROUP ELEMENTS TO ESTABLISH MEANING

The grouping of elements according to similarity and proximity has already been examined separately in this chapter. However, those elements that are similar and in good proximity create another relationship. Be aware that elements that are similar in position or in size, and that have good proximity, may also be seen as similar in shape. For example, when a person rests his hands on his hips, the triangular shapes formed are likely to be grouped.

Another aspect of this concept is similarity of meaning. The connection made between a product and the results and benefits of its use plays a very large role in advertising. For example, most ads imply that if you use the product you will have fun, be like, or already are like the people shown in the photograph. Cosmetics ads rely on the image created to generate sales of their product. Ideally, the image fits how consumers see or would like to see themselves, and consequently, it affects a consumer's decision to purchase the product.

This connection is most vivid when the product itself is shown in the ad. Your eye sees a woman wearing a certain type of make up. A handsome man is standing next to her. You put the two together and come to the conclusion that this is how you will see yourself, or be seen, if you use that make up. When done effectively, similarity of meaning creates a lasting image in the consumer's mind. The campaign created for Marlboro is so well established that as soon as the cowboy with a cigarette is seen, you immediately think of the Marlboro Man.

Be aware that elements that are similar in position or in size, and that have good proximity, may also be seen as similar in shape. For example, when a person rests his hands on his hips, the triangular shapes formed are likely to be grouped.

This photograph was shot aboard the USS *Kennedy* heading towards Manhattan. I was on the flight deck as it approached the Verrazano Bridge. Shot for the U.S. Navy, it illustrates the effective use of similarity and proximity. Similarity—the sailors clasping their hands behind their backs—and the proximity front to back of the sailors starts the visual motion. Shapes are formed by the sailors, their stance, the curve of their hats. All of this keeps the eye moving. The stripes and circles on the deck repeat the circles of the hats and stripes on the sailors' pants. The triangular shapes in the structure of the bridge are repeated in the shape of the clasped hands. Similarity and proximity establish many groupings that lead the eye around the frame.

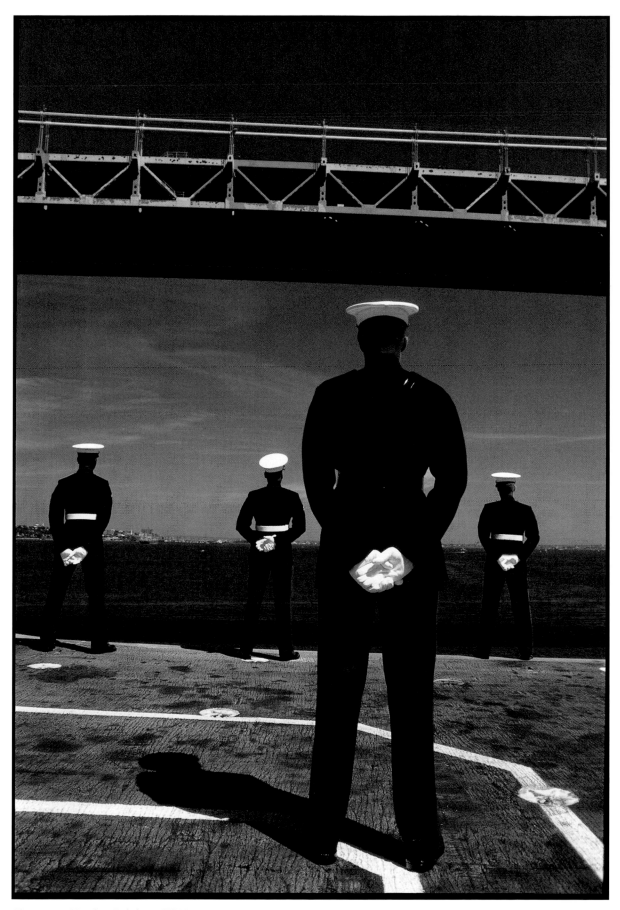

35mm camera, 35mm lens, Kodachrome PKR64

SIMILAR SIZE
GROUP ELEMENTS BY SIMILARITY OF SIZE

When you walk into a clothing store, you will see logic in the organization of the clothes. You can find what you are looking for with a minimum amount of effort. The styles on the rack are all different, but due to organization by similarity of size, you see the coats as being related. Your mind groups them together and you can see them as patterns. It is this ability to group and see in a pattern that allows your eye to move along the rack. Consider how long it takes to shop during a sale when you must stop and check the size of each item before you can try it on. This process of organization by similar size is a constant in our daily lives. Cars, pizzas, shoes, pool cues, prices, cars, televisions, and people are all organized according to size.

Think of how much attention a very small or an extremely tall person can generate in a crowd. Your eye stops, and you focus your attention on the dissimilar size of these people in comparison to the rest of the group. After you have noticed these people, your eye continues to scan in a horizontal, vertical, or diagonal motion across their faces.

The knowledge that grouping can result in seeing in patterns offers insight into how the mind will read and organize the information in a photograph. Patterns create visual motion that is vertical, horizontal, diagonal, or circular. The example relies heavily on grouping by size into patterns to create movement within the frame.

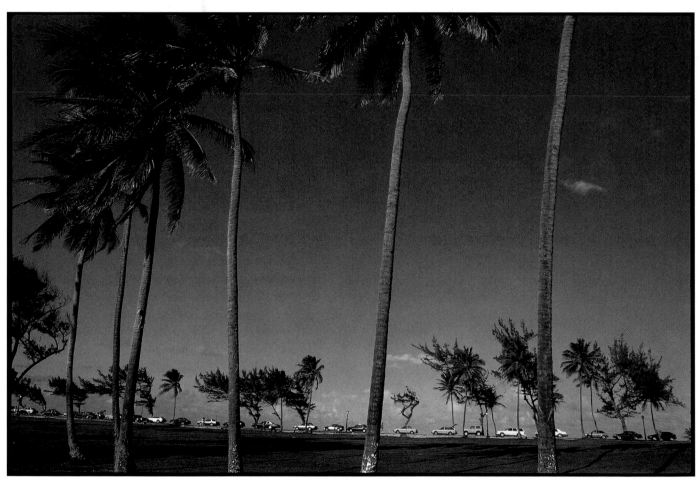

35mm camera, 24mm lens, Kodachrome PKR64

This scene, found in Old San Juan, Puerto Rico, intrigued me, even though it did not tell a story or communicate anything. I still, enjoy what appealed to me initially. It has a visual rhythm. It is the proximity of trees of dissimilar height in the foreground and background that starts and continues the visual motion. The similar size of the cars and the palms themselves add to the motion and rhythm of this shot.

SIMILAR TEXTURE
GROUP ELEMENTS USING TEXTURES

You are about to begin the paint job that you have been neglecting. As you look for the sandpaper you need, you group the paper's texture according to the phases of the job. In the store, it has been divided according to texture, to ease the customer's search. Your mind groups elements according to similarity of texture. It is this ability that also allows you to see patterns.

This sensory approach to grouping can be applied to photography. It is made between what is seen and the memory of how it actually feels to the touch. For example, if you see an object that is wet, you perceive it as being smooth. The grouping of elements of similar texture within a photograph is another element that creates visual motion throughout the frame.

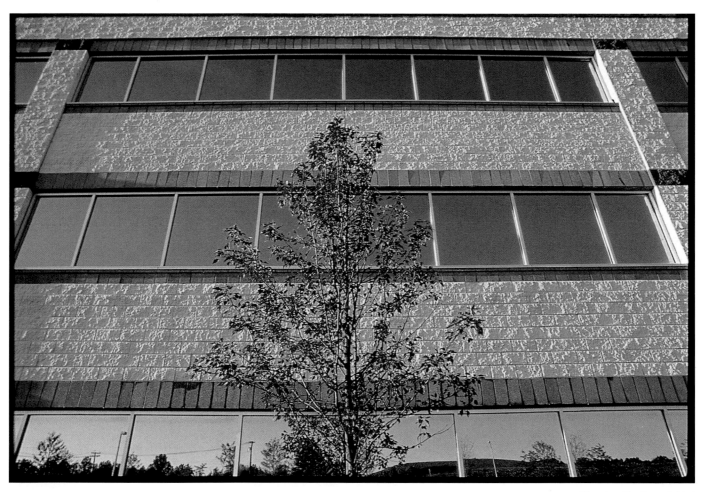

24mm lens, Ektachrome E100VS

The one characteristic that defines this photograph, shot for client Clayton Block, is its tactile quality. A variety of texture can be seen. Shot right after sunrise, the yellowish light skims the surface of the building, enhancing the perception of texture. The eye moves from the texture of the tree to the raised texture of the block façade onto the black bricks to the vertical blocks, and then, the windows. It is the constant grouping of elements according to similar texture shape and size that creates visual motion.

Your mind groups elements according to similarity of texture. It is this ability that also allows you to see patterns.

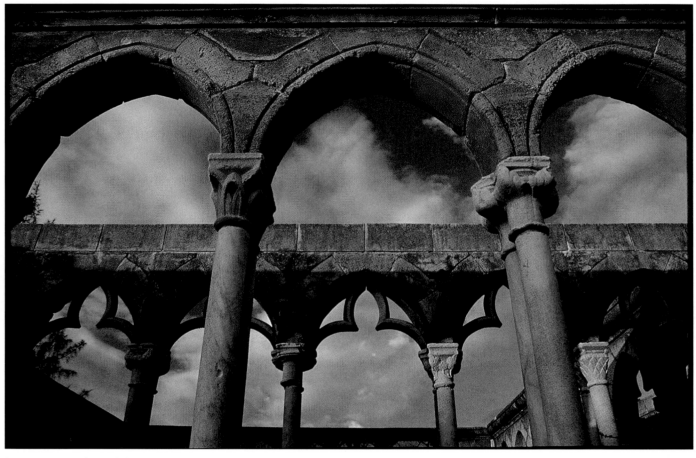

35mm camera, 28mm lens, Kodachrome PKR64

This image, shot in the Bahamas, is filled with elements of similar texture and shape. The texture of the columns, and their proximity, brings your eye from front to back. Repetition of the texture and shape of the stone above the arches also creates movement around the frame. Even the texture of the clouds seen through the arches adds to the visual movement.

FRAME WITHIN A FRAME
ENHANCE THE PERCEPTION OF FIGURE

By applying similarity of shape in a different way, the photographer can create a frame within a frame. This effect is achieved by the repeated use of similar shapes to frame the figure. The technique can enhance the importance and, consequently, the perception of figure. On another level, the technique can be instrumental in creating a good figure/ground flip.

In addition, this specific application of similarity of shape fosters a repetition that initiates movement within the photograph. It may also be used to add other dimensions to enhance the image. The perception of depth may be made more obvious. For example, a person can be aggrandized in portraiture. Some aspects of surrealism or illusion may be evoked by the use of the frame within a frame. The following photographs were chosen to illustrate this concept, but other images throughout the book contain a frame within a frame if you look for them.

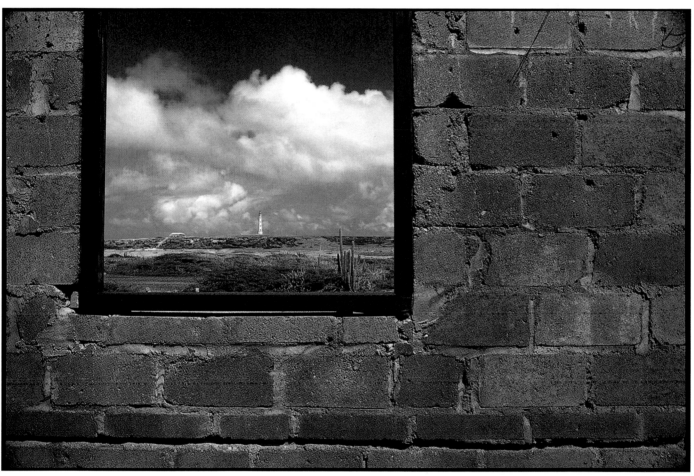

35mm camera, 28mm lens, Kodachrome PKR64

Walking around Aruba in the midday sun, I came across an abandoned building. The texture and shape of the bricks reinforce the shape of the red window frame. The shape of the lighthouse is repeated in the shape of the cacti. The rocks and building in the background repeat the texture of the bricks in the foreground. The light at high noon is not very appealing or flattering; however, in this shot it is the lack of contrast due to the flat light that facilitates the eye's movement around the frame.

33

CONTINUATION
GROUP UNINTERRUPTED VISUAL ELEMENTS

As you drive down the highway you use the broken yellow lines as a guide to stay on the road. Since the lines are similar, have good proximity, and are equally spaced, your mind sees the lines as continuous. The grouping of similar visual elements with the fewest interruptions allows the mind to see the elements as continuous.

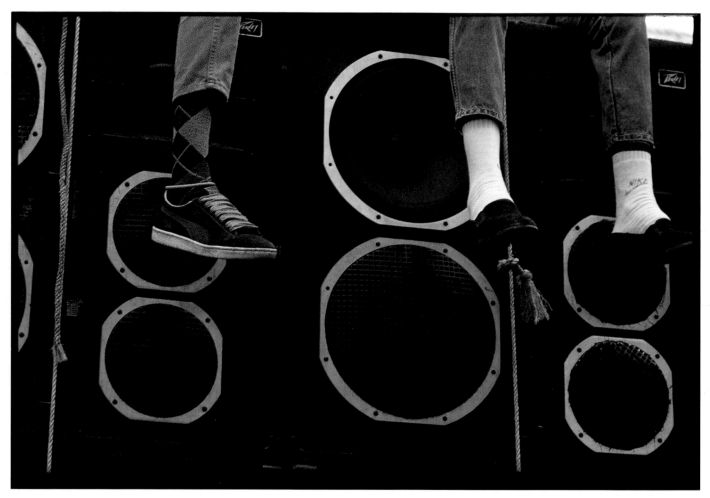

35mm camera, 100mm lens, Kodachrome PKR64

During an Independence Day celebration in St. Kitts, this scene of a wall of speakers with dangling legs and feet caught my eye. Only two speakers are seen completely. They are the only uninterrupted visual elements. The rest are cropped or obscured by legs. Cropped ropes move the eye up and down, and the unseen leg and foot of the person with the yellow pants adds to the visual impact and continuing movement around the frame.

The grouping of similar visual elements with the fewest interruptions allows the mind to see the elements as continuous.

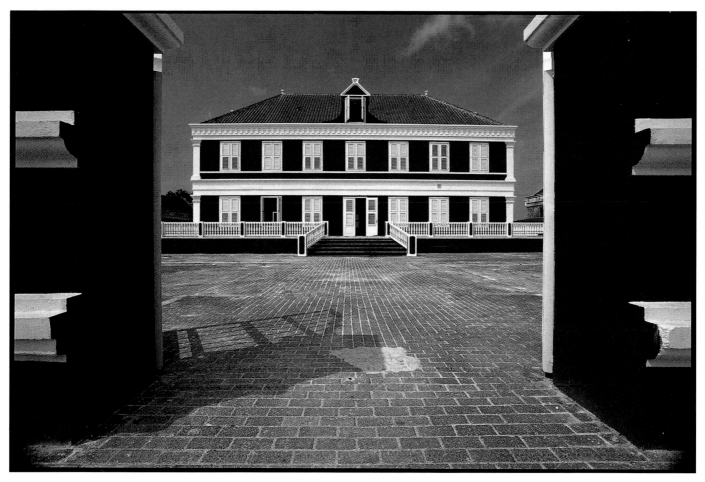

35mm camera, 24mm lens, Kodachrome PKR64

While in Curaçao on a shoot, I visited the historic district, which was in the midst of extensive renovation. This shot has a continuous visual motion. (It is also an excellent example of frame within a frame.) Your eye moves from the lines formed by the bricks to the roof and then to the red-and-white fence. Then movement continues to the windows and then back to the red-and-white pillars that frame the shot. The horizontal white lines bring you back to the building.

CLOSURE
SEE CLOSURE OF SHAPE AND LINE

When you see a portrait of someone from the waist up with the elbows cropped out, do you assume that they have no elbows and no bottom half to their body? Of course not. Your mind completes the image of the body from memory, and the portrait is seen as complete. There is no reason to expect that the rest of the person does not exist. Because your mind automatically completes (closes) the figure, people who have lost a limb or are affected by physical impediments are shown full-length in a photograph in order to define the loss.

You see shapes and lines that are familiar, as complete (closed) rather than incomplete. This is a continuous, automatic, unconscious, and necessary process. Think of how often you see only a portion of an object and "see" it as complete. For example, as you walk down a street, you see half a clock, the front of a cab, the back of a bus. They are familiar shapes so your mind completes them automatically. Imagine how complicated and time-consuming life would be if you had to see a whole cab to know what it was.

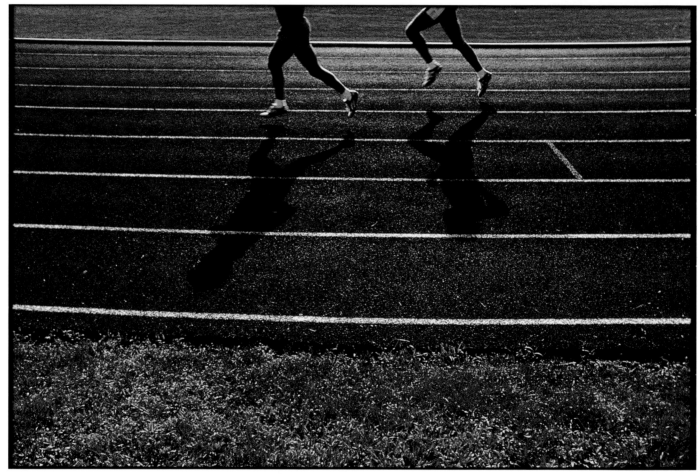

35mm camera, 100mm lens, Kodachrome PKR64

This shot, done for client Dreyfus, is a very clear example of how your mind automatically creates closure. The shadows of the runners complete the actual bodies that have been cropped above. Even though the track is seen only fractionally, your mind sees it as complete. Your eye moves back and forth across the frame, because of the lines of the track. One very important aesthetic point to consider: neither runner's feet are touching the ground. This proximity and visual tension between shadows and feet generate motion side to side and up and down.

For lines or shapes to be seen as closed, they must have good proximity, be similar, and form a continuous element. For example, you look from a mountaintop and see a road that winds downward. Periodically, the road is interrupted by trees, yet you will see the line of road as closed (complete) only if the space between the trees is not too large. Closure of shape and line is another way in which your mind organizes information.

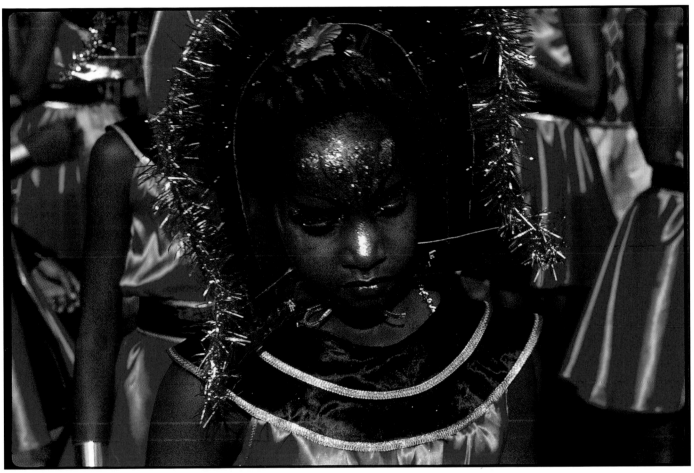

35mm camera, 100mm lens Kodachrome PKR64

This shot is an example of closure and selective focus. This girl and the vibrant colors caught my eye during Carnival on Martinique. As you look at this image, you will notice that not one person is shown in entirety. The girl, in focus, has her headdress cropped. Her body too is cropped at the neckline. To her left you see a cropped arm and to her right the two halves of two other girls' dresses. It is the mind's completion of what is cropped that creates visual motion.

Closure of shape and line is another way in which your mind organizes information.

39

LOOK BEFORE YOU SEE

35mm camera, 100mm lens, Kodachrome PKR64

EXERCISES TO REFINE YOUR VISION

Shoot however and whatever you want. Don't listen to anybody else, just go in the direction you have chosen.

— WALKER EVANS

YOUR EYE IS A MUSCLE THAT MUST BE DEVELOPED, DISCIPLINED, REFINED, AND THEN freed. This chapter illustrates the thought process that goes through a photographer's mind when shooting. It will help to refine your vision. As a photographer looks through the lens, questions arise on both a conscious and unconscious level, illustrated in the exercises below.

Six months after I first began to take photographs, I had the rare opportunity to meet and spend time with the legendary Walker Evans. He offered to look at my images. He told me, "Shoot however and whatever you want. Don't listen to anybody else, just go in the direction you have chosen. The basics are here, but you need to *look before you see.*" I was too young at the time to understand the last phrase. Two years later, I began to get a glimmer of what he meant.

The exercises in this chapter were designed to help you to discover your own particular vision. However, they will not give you the talent to see. People who have this ability are masters of their craft. It is a gift that is developed and refined over time. Most photographers are excellent technicians, but very few have the ability to see. This is not meant to discourage you but only to put things into perspective.

As a photographer looks through the lens, questions arise on both a conscious and unconscious level...

For maximum benefit, I suggest you invest a few days and six to twelve rolls of film (either black-and-white or color) in doing the exercises. You will learn more by doing than just by reading them. Also, when you have done them yourself, they will become more real and tangible. You will find them worthwhile when your photographs begin to resemble more closely what you intended. Since there is no time limit, take your time and think the shots out. Keep in mind that each exercise may not result in a good or great photograph, but learning from your mistakes will make your future photographs better.

Personally, I learn the most from the images that do not succeed completely. I ask questions that address visual problems. What did I miss? What could I have done differently? To become a better photographer is to be willing to learn and see something new.

After years of peering through the viewfinder of a camera, the shape of the frame for all camera formats and the angle of view of most lenses are engraved in my mind. As I look around a room or walk down a street, I constantly frame images in my mind. This process is continuous, though not necessarily conscious. Hopefully, by practicing these exercises, you will gain a basic idea of what is possible. Their purpose is to assist you in looking at the world with greater awareness.

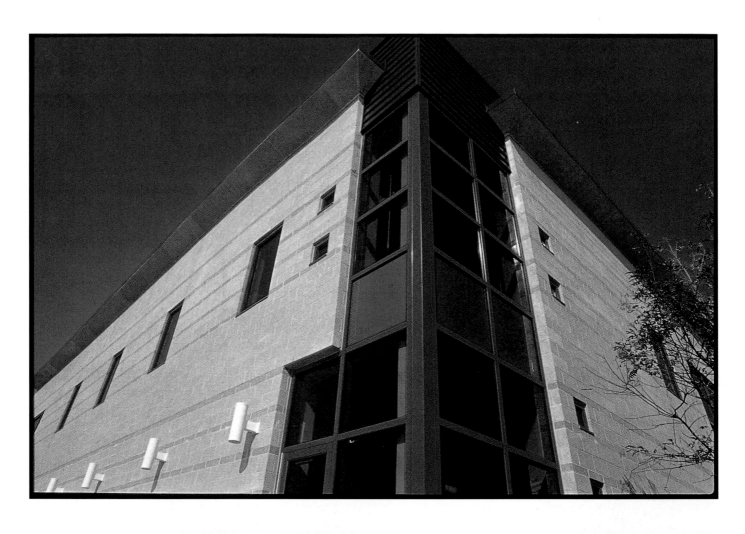

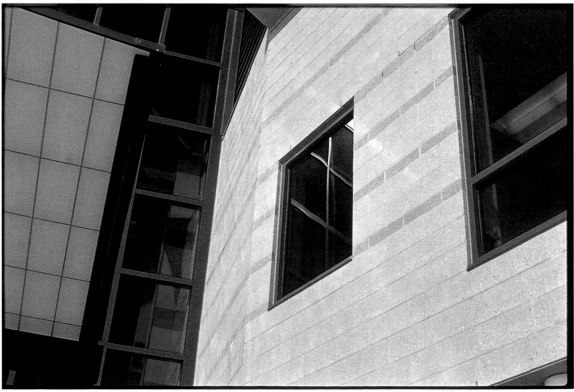

A CAT'S-EYE VIEW
FIND A FRESH PERSPECTIVE

For some reason, many people believe that all photographs should be made with the photographer standing, knees locked, in an upright position. Shooting from one position severely limits your ability to see the world in different ways.

Look at the world from various angles. Try climbing a tree, lying on the ground, or kneeling for a fresh perspective. Different angles do provide interesting and different ways of seeing things.

Photographs of a steel raise for client Schoor DePalma are used to illustrate this section. Here, each image is different due to changing camera angle and lens choice. By changing camera angle, you force yourself to look and see differently.

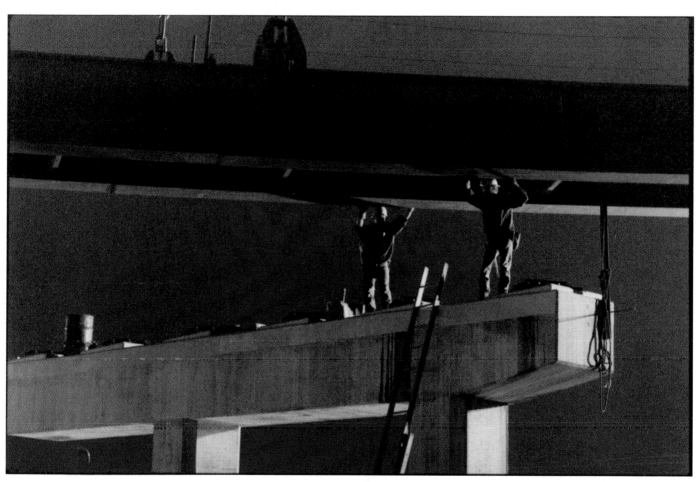

35mm camera, 20mm–300mm lenses,
Kodacolor Royal Gold 100

This is one of many shoots done for the engineering firm Schoor DePalma. Since this client designs a lot of bridge construction, it needed images that described the process. To make the final images interesting, they were shot in daylight and at night (pushing film), varying camera angle location and lens selection. Whether you are shooting for yourself or for a client, you have to push yourself by trying different camera angles to make your shots look different.

Shooting from one position severely limits your ability to see the world in different ways.

VISUAL EXERCISE

As a visual exercise, you should take one roll of film and imagine the world from the perspective of a cat. This does not mean crawling around the house on your stomach, taking portraits of your cat! In the event you have an aversion to cats, photograph from a squirrel's point of view.

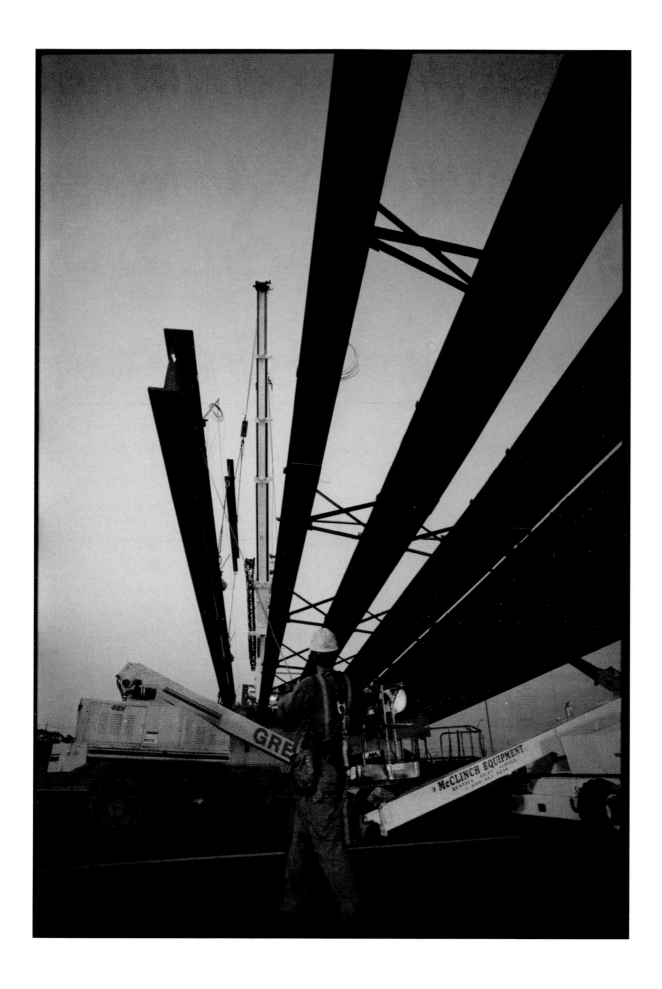

MOVE IN CLOSER
ELIMINATE UNWANTED DETAILS

The most common error that most amateur photographers make is not getting close enough to the subject. In many respects, photography is a subtractive process. You selectively delete information and details that you do not want in the final image. Being too far from your subject means that you are including details that detract from the subject. As you move closer, you delete unwanted details. Whether you move closer physically or use a longer lens, the final image will be easier to read and communicate far more effectively.

While on assignment in Jamaica, I was shooting in a lush tropical garden. It was overcast and the colors were vibrant as my wife Amie and I walked along the pathway. The result of moving in closer to the subject, as shown in these two photographs, is quite dramatic.

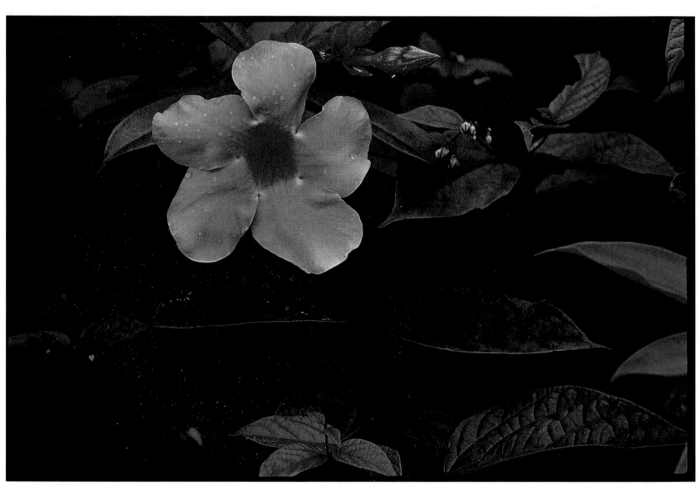

35mm camera, 28mm lens Kodachrome 64

Walking through a botanical garden in Jamaica, I came across this scene of yellow flowers. The rain had just ended and both the leaves and flowers still had drops of water on them. I remember that even before clicking the shutter on the first shot (the wider view), I said to myself, "This is not it." The true appeal of the scene was the rich and vibrant color of one yellow flower. Switching from a 28mm lens to a 100mm macro to isolate and focus on what was important resulted in the deletion of all the unnecessary elements

50

Being too far from your subject means that you are including details that detract from the subject.

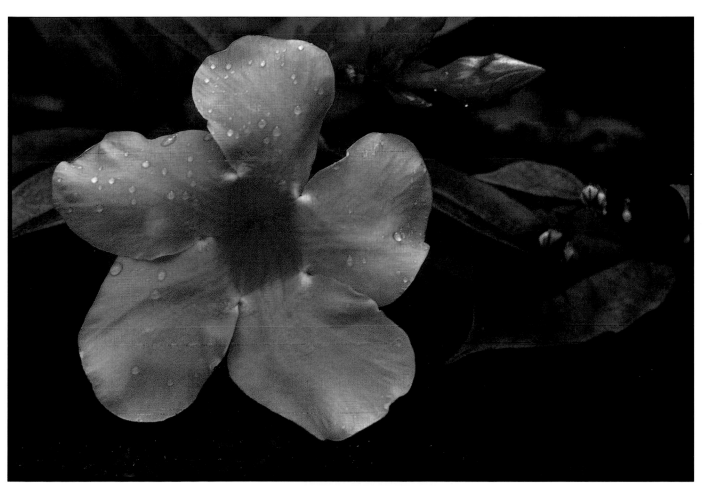

35mm camera, 100mm macro, Kodachrome 64

VISUAL EXERCISE

Take two rolls of film and go out shooting. Each time you decide to take a picture, immediately shoot five more frames of the same subject, moving closer to the subject with each shot. This exercise develops the conscious process of what a professional photographer does unconsciously every time he shoots.

35mm lens, Kodacolor 11

Surprisingly, this image is the logical conclusion to the ideas sketched throughout the roll. What was lacking in the previous shots has been understood and resolved here. The strengths of color, graphics, space, portions of objects, and pieces in between two elements have all been incorporated in this shot.

VISUAL EXERCISE

I have found this exercise to be extremely useful in breaking out of a creative rut or slump. The key is to rely on your intuition and first impressions. Go to a location that you have been before, but one that is very different from where you would normally shoot. For example, if you are a nature buff, then go and shoot in a city. The idea is to shoot whatever strikes your eye. Do not spend hours composing, changing lenses, and thinking out how the shot looks. Just click the shutter and move on. In one hour, you should shoot two to four rolls of film. In this case, a self-imposed time frame is important. It makes it necessary for you to respond to what you see and not think about what you are shooting. I suggest that you shoot negative film because it is easier to read the results from a contact sheet than to evaluate slides seen sequentially on a projector. Proximity, explained in Chapter 1, facilitates learning by comparison.

WAIT FOR THE MOMENT
LET PATIENCE BE YOUR GUIDE

A photographer must be continuously aware not only of what is in front of the camera but the entire field of view. With this awareness comes a sense of when the shot is right and when it is missing an element that would make the image complete. Sometimes the solution could be a change in framing or a different lens. It may become apparent that there is one missing element that would make the shot work. This is a judgment call. Once you make this decision, you have to consider the likelihood of this element's inclusion in the frame. If you are standing in the desert at dawn, it is unlikely that a car or a woman on horseback will cruise into the frame. However, a bird and its shadow may work just as well. To add that one missing element is to make the shot complete.

This ability to see and anticipate the moment separates the great news, sports, and fashion photographs from the good ones. A great photograph is captured in that split second when an eyebrow is lifted, a head is turned, a grimace

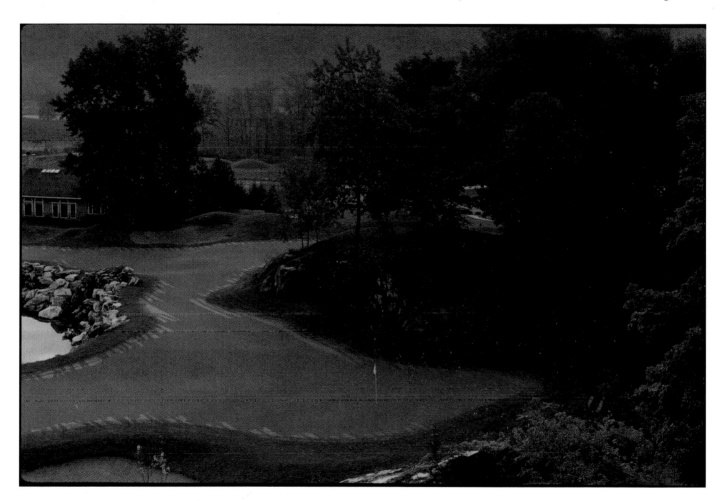

This image is basically a warm up shot. Is it necessary to shoot some film the way an athlete warms up before a game? No. In fact, I find that it is usually the first shots that are the best. However, it is a habit, or superstition, that makes me feel better.

forms, or the climax of an event occurs. A motor drive is a terrific tool, however it does not guarantee results if you have no idea what you were waiting for in the first place. Photographic equipment is no substitute for a good eye. Seeing what is missing is first; being aware of all that is in front of you is second; and anticipating what will occur is third.

This series of shots, made for a client, K. Hovnanian, at Crystal Springs, is an excellent example of waiting for the moment. Up before sunrise, as my assistant and stylist slept, I borrowed a golf cart and proceeded to drive the course.

On that frost-filled morning, the purpose was to find the vantage to shoot one great shot that showed the beauty of the course. Groundskeepers with squeegees were removing the dew from the greens in advance of the dedicated golfers. After nine holes, passing only a few hardy golfers along the way, I found the perfect location to shoot from. Looking at the scene, I realized that I needed golfers in the shot, and so I waited and waited and waited. The shots in this sequence illustrate the importance of waiting for the moment.

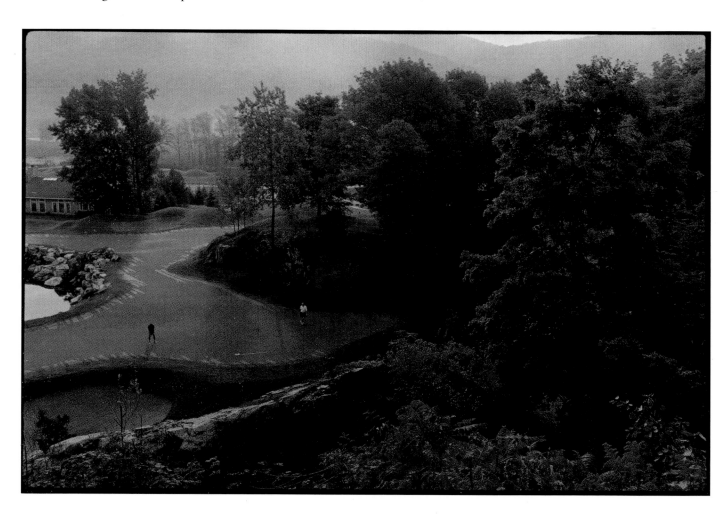

By the time the golfers had arrived, the sun was just about to rise over the mountains and shine directly into the lens. Time was of the essence. I moved the camera over to include the flowers and stone wall to frame the scene. As I shot this, I knew that the golfers were just not in the right position, so I watched and waited.

A great photograph is captured in that split second when an eyebrow is lifted, a head is turned, a grimace forms, or the climax of an event occurs.

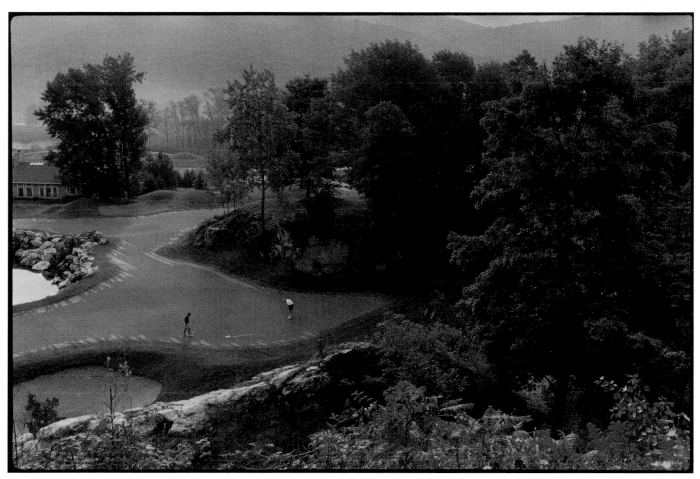

35mm camera, 50mm lens, Royal Gold Kodacolor 100

Finally, the golfers were in the position that worked visually. Right after this series of shots, the sunlight began hitting the lens, removing the possibility of further shots. The keys to getting this shot on film were preparation, patience, and anticipation. I had to watch and wait for events to unfold before the lens.

WAIT FOR THE LIGHT
CAPTURE THE BEST LIGHT

There is a magical quality to the light just before and after the sun rises and sets. Shooting at these times of day can certainly add a dramatic quality to a photograph. Because too many other factors go into the creation of a great shot, light alone does not guarantee a terrific image. Yet there is really only one moment when the light is perfect for a subject. It is far more likely that you will have to wait for the light to be right than for it to be perfect when you arrive on the scene. Usually, a photographer waits for the sun to rise or set a bit, or for the clouds to shift.

As you wait for the light to change, you need to watch how the quality of light affects your subject. You may find that what you are waiting for is still not the best light. The feathered light of the sun coming from behind a cloud may be far more appropriate than a strong, direct light.

Don't read a book or change the oil in your car while waiting. You have to look to see how the light changes to know which light is best.

These shots were taken for a New York City investment banking firm. I scouted the position in advance, so all the interior and most of the exterior shots were finished earlier in the day. The best shots turned out to be these ones, taken at the end of the day. An hour before the optimum light, heavy clouds began to roll in. The cloud cover dictated that the shot be done at dusk or night instead. So, I waited and waited and waited. In photography, as in life, sometimes things do not go as planned. The lessons from this series of images are wait for the light, watch the sky, be prepared, and, when in doubt, shoot.

35mm camera, 200mm lens Kodachrome PKR64

Just before sunset, a small patch of blue sky appeared. The shot was already framed and it was ready to meter and shoot. Thirty seconds later the sun was gone. Patience in waiting for the light paid off.

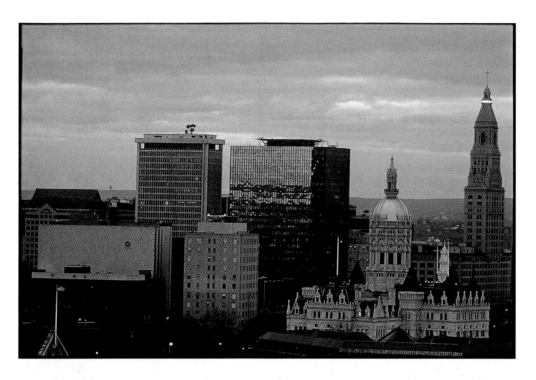

As the sunset began to fade, another small patch of blue sky let the sun's rays hit the city. The first shot was right but I shot this one for insurance.

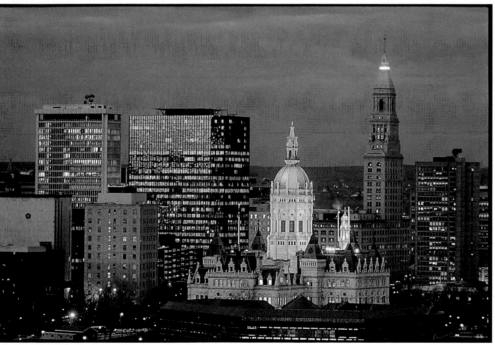

This was the scene I expected when the clouds rolled in. The only choices were to change the framing to compensate for the lack of sunlight and to wait as the lights of the city grew brighter.

. . . there is really only one moment when the light is perfect for a subject.

VISUAL EXERCISE

The next time you shoot on a day when the sun is constantly going in and out of the clouds, take a series of pictures while the light is changing. Shoot when it is overcast, when the sun begins to emerge, and then when the light is stronger. By doing this you will see the process of working with changing light more clearly than examples in any book can show you. The subtleties and the radical effect of the change in light are important for you to understand. For the most dramatic effects, shoot this exercise either in the early morning or late afternoon.

INSTANT RESPONSE
TRUST YOUR INSTINCTS

A photographer must always be ready for the unexpected. This section illustrates how to use your intuition as well as how to build up your response time. Remember, for the few shots that are successful, there are hundreds upon hundreds that fail. It is a matter of being in the right place at the right time and being lucky enough to seize the opportunity when it occurs. This section is an extension and variation of the previous one. The basic difference lies in the reliance on intuition and shooting without judgment as to the value of the shot.

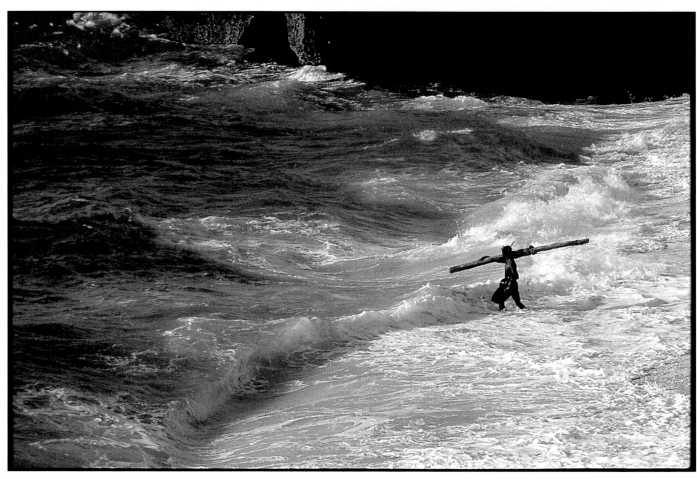

35mm camera, 100mm lens, Kodachrome PKR64

I was busy shooting on a hill overlooking a hotel beach in Barbados. For some reason, I turned around to see this guy walking into the ocean with a large pole over his shoulder. There was only time to focus and shoot, and then he was gone from view. Two questions remain unanswered: What made me turn around in the middle of a shoot and what the hell he was doing with that pole!

VISUAL EXERCISE

To quicken your reflexes, I would suggest shooting events that have large groups of people. County fairs, parades, and amusement parks are good places to try it out. One point to keep in mind is that all these people are moving continuously. You should also move constantly looking for shots. If you don't move, you will find yourself dazzled by the motion of the people.

. . . for the few shots that are successful, there are hundreds upon hundreds that fail.

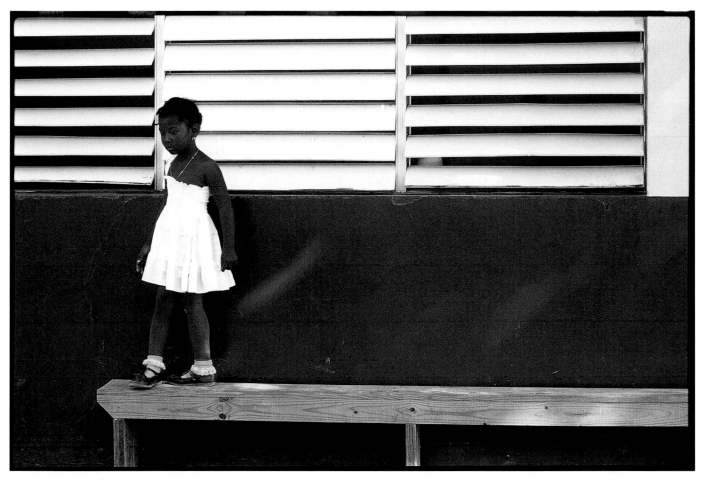

35mm camera, 100 mm lens, Kodachrome PKR64

On the same shoot in Barbados, we were walking in the capital, Bridgetown. We approached a school as all the kids were exiting. As we arrived at the school, the sun's dappled rays started to hit the wall. Knowing that school was out, I stood there waiting with camera in hand, hoping that there were other students left inside. Within seconds, this little girl exited the door and ran back and forth on the bench. She then left to join her friends. If the camera was up to my eye when she came outside, it probably would have spooked her, and the shot would have been lost. This shot is truly a combination of an instant response to a scene and luck that the sole child left would jump up on the bench.

ANIMATION
A DIFFERENT WAY OF SEEING

When you animate an object, you give it a breath of life that it didn't have originally. The object is shown as something more and something different than it really is. Success is predicated on the viewer's ability to see the image and relate it to something familiar. For example, in cartoons the front of a car can be depicted as a face. The mind makes this assimilation and defines the unfamiliar by relating it to some kind of familiar form. The design of an image can take advantage of this fact to animate an object.

Precise design removes details that would detract from the success of the photograph. All tools available to the photographer are used to create this effect. Selection of focus, lens, and filters are decided according to the subject.

There are two possible ways to animate an object. The first is to select an object that is an inanimate representation of something that is living. Mannequins or parade floats fall into this category. The other way to animate a subject is to take the mundane and portray it in such a way as to make it look alive. The photographer's vision, the use of the frame, and the tools available make the difference. Obviously, it is far more difficult to animate a fire hydrant than a mannequin.

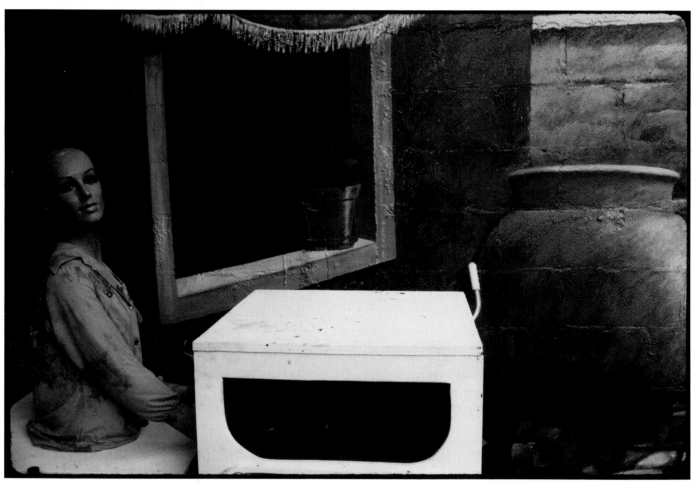

35mm camera, 50mm lens, Kodachrome 64

I find that when I shoot for myself, there are times when I walk to and shoot in an area where I did not expect to be. While in Hawaii on vacation, I was aimlessly wandering from main thoroughfares to alleyways and came across this scene. Mannequins appear animated because they are manufactured images of ourselves. In this shot, my first color photograph, the contrast of the mannequin against the painted wall makes the scene surreal.

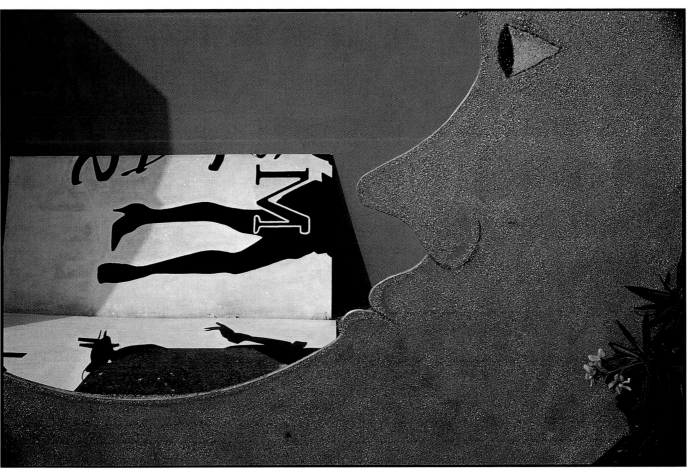

35mm camera, 28mm lens, Kodachrome PKR64

Sometimes the key to finding and ultimately making a good photograph means looking beyond what is in front of your camera. I had just shot the front of a building in Curaçao, when for some unknown reason I went around to the rear. This moon appears animated because of the contrast of the pink flowers and the legs on a discarded billboard. Owing to the proximity between the nose and lips of the moon and the legs on the billboard, the moon appears to be looking at them and about to whistle. It is important to note that I could have changed this image by shooting lower and deleting the billboard. However, the only result would have been a less interesting image.

VISUAL EXERCISE

Shoot an entire roll of animated subjects. The key to this exercise is not the subject itself but rather how you portray it. Cars, buses, trains, and mannequins, for example, are all obvious choices. Because you will focus your attention on one type of image and effect, it will take time and patience. However, the goal is to train your eye to see more and in a different way. Although more frustrating than many of the other exercises in this section, it offers a valuable lesson.

The mind . . . defines the unfamiliar by relating it to some kind of familiar form.

MOTION
CAPTURE MOTION

Between the high shutter speeds on a camera and the use of electronic flash, the motion of moving objects can be effectively frozen. However, the use of these tools is determined by the effect that you want in the image. No written rule says everything must be sharp, with no sign of motion. A blur of movement can give a sense of power, mood, speed, drama, wonder, or unreality. The most readily available source for seeing how motion is captured is the sports and news photography you find in magazines and newspapers. This usage is as selective as framing and lens choice.

Visually, motion adds another dimension to a photograph. Motion can separate figure and ground, create visual motion through creating similar shapes, continuation, and closure. It is a visual tool that should be understood and used as selectively as any other tool.

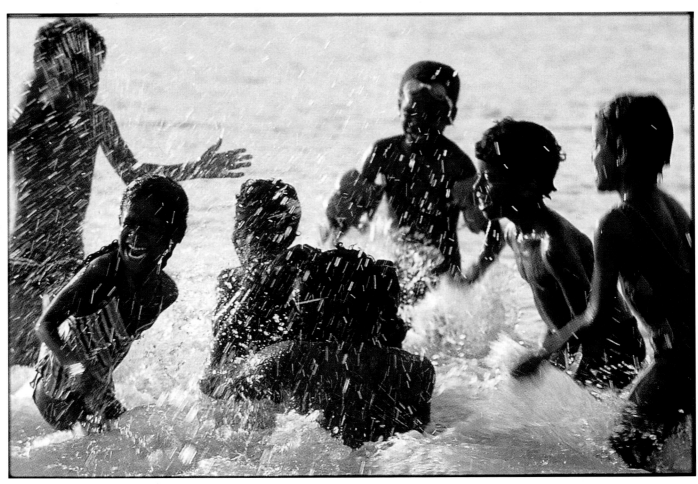

35mm camera, 200mm, Kodachrome PKR64

While shooting in Curaçao on a weekday, I found there were not many people on the beach. At the end of the day, a large family arrived for a quick dip. As they proceeded into the water, I followed them to the water's edge and waited. Soon the children began to play. Using a slow shutter speed and selective focus, I waited for the action to unfold. The blur of motion of the kids at play and the blur of the spraying water adds to the motion and emotion of this shot.

A blur of movement can give a sense of power, mood, speed, drama, wonder, or unreality.

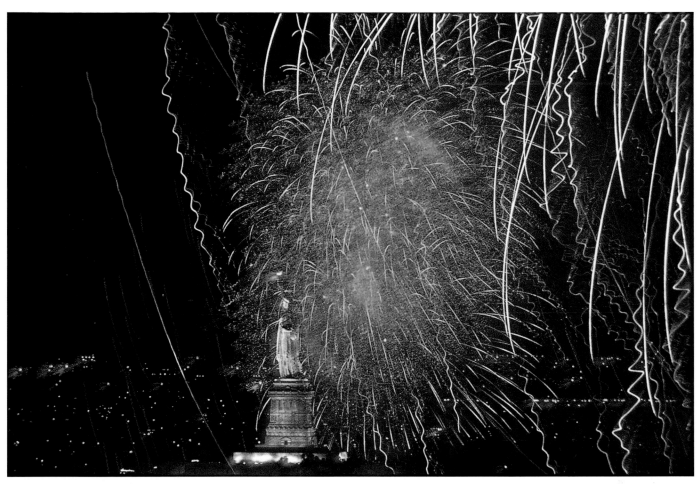

35mm camera, 400mm lens, Kodachrome PKR64

Shooting fireworks is a combination of anticipation, experience, and a bit of luck. This shot, done for the Liberty Centennial, involved an 8- to 12-second time exposure. The blur of the trails of exploding fireworks creates a fiery burst of color that surrounds the Statue of Liberty.

VISUAL EXERCISE

Select scenes that offer you a choice of how motion can be portrayed. Photograph these scenes with shutter speeds that range from 1/8 to 1/250 of a second. Possible options include busy intersections, marathons, bike races, and other sporting events that you know well. Application of long time exposures (with or without a flash) is not the only option available. Since the rendering of motion is a tool that is used selectively, experience and judgment gained through experimentation will allow the photographer to make a decision. First, you must see for yourself the effects that can be created before you can make an informed decision.

FILM AND LIGHT

35mm camera, 35mm lens, Kodachrome PKR64

DESIGN CONTROLS FOR BLACK-AND-WHITE AND COLOR

The craft of photography is visualized in the beauty of a good black-and-white print, a translation of the world around us into shades of gray.

THIS CHAPTER PROVIDES AN OVERVIEW OF HOW IMAGES ARE RENDERED UNDER DIFFERENT kinds of light for both black-and-white and color film. Included is a discussion of the effects of paper and processing. The chapter concludes with photographs of two different subjects shot both in black-and-white and color to show how the two films render the same image under two different kinds of light. This should provide you with a starting point in your exploration of the possibilities available to you in shooting in black-and-white or color.

A good black-and-white image is very special. It doesn't strike the same nerve or evoke the same response as a color image; but beauty, power, and emotion are still evident. The world is given a totally different interpretation. Because the image is a translation that lacks the reality of color, it generates more of an intellectual response. The craft of photography is visualized in the beauty of a good black-and-white print, a translation of the world around us into shades of gray.

It is necessary to understand the potential, the controls, and the limitations in the black-and-white process in order to make a strong color photograph. Knowledge of the wide variety of controls available within the black-and-white process, from exposure of film to the final print, provides a context in which to view the very limited options available in color. From a design perspective, this large system of controls offers numerous ways to alter and enhance the final print. Each decision made has an effect on the final image. As a result, each step of the process needs to be understood and thought out before a decision can be made.

Film Processing

The three controls that can have the most radical effects on the final image are: the type of filters used during film exposure, the type of film, and the method of development.

Filters The choice of filter will affect how bright or dark colors are seen by the film. Although the film is black-and-white, you are still shooting a color scene. Yellow, red, and polarizing filters are the most commonly used ones. A red filter will render red as a lighter gray, while blue and green will look darker.

Film Each film produces a different size grain. The lower the ASA, the finer the grain. The choice of developer further alters the size and the shape of grain in black-and-white film.

Film and Developer Another important decision is the combination of exposure, film, and developer used. Numerous choices are available, and they have different effects. For example, Kodak's Tri-X film developed in Kodak D-76 will produce sharp grain and contrasty tonality. Edwal F-G7 has a softer grain and a wider tonal range. Acufine, however, produces sharper grain, larger grain, and contrasty tone on pushed film. A decision must be made before film is exposed as to what the final image should look like in order to best utilize these controls.

Print Processing

Two of the most important controls are the choice of printing paper and paper developer.

Paper Each brand of fiber-based paper has different characteristics. Color and contrast are the two criteria, but even these qualities can be altered by the choice of developer and toning.

Paper Developer Through changes in dilution and development times, paper developer is a tool that can be used to widely expand the tonal range or increase the contrast of the final print.

Although the real key is to develop, train, and refine your vision—to see in shades of gray rather than color—it is a completely different way of seeing that comes with time and experience. Knowing and using all the controls, tools, and limitations of the process will be worthless if the eye lacks the vision to see the subject in terms of its translation into black and white.

Overcast Light

When clouds block the strong directional light of the sun, a passive quality to the light is left in its place. The illumination that is seen is gentle or soft due to its lack of definition. Color is neither diluted nor strengthened by the highlights and shadows from the sun. Since the contrast is low (flat), the limited latitude of color film can maintain all the detail within the scene. However, in the case of backlighting or a dark scene with overcast sky, selective exposure for one area or another is still required.

The rendering of texture, shape, and contrast is far subtler in translation because it is defined by the subject rather than the direction of the light. Consequently, overcast lighting is not the perfect light for every subject. When used correctly, the results can be dynamic and subtle at the same time.

I was on assignment in Jamaica to capture the beauty of the island. One of the subjects to shoot was a tropical garden. Selective focus makes the flower the hero of the shot. The out-of-focus leaves repeat the curve of the flowers. Usually, the rich, vibrant colors and texture of foliage are more vividly rendered and even appears more tactile when shot on an overcast day.

35mm camera, 100mm macro lens, Kodachrome PKR64

*When used correctly, the
results can be dynamic and
subtle at the same time.*

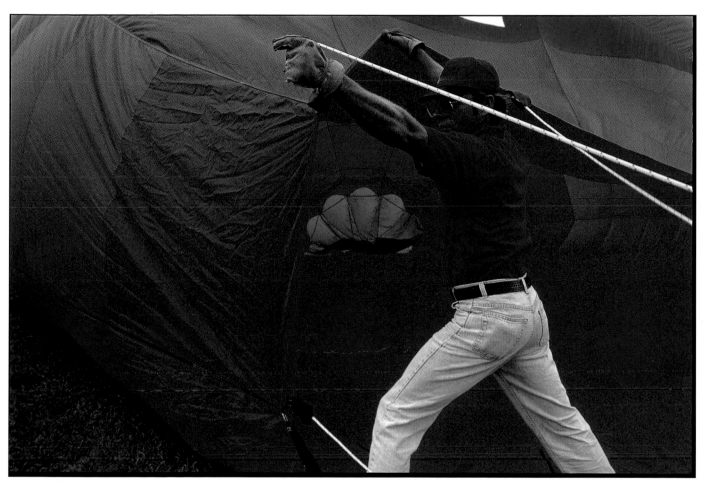

35mm camera, 28mm lens, Kodachrome PKR64

Shooting for yourself is important. Personally, I pick things that I am
interested in but have never shot before. I always enjoyed hot-air balloons
but had never shot one before. On the morning of this shoot, the sun gave
way to thick clouds, so I had to find a way to avoid showing the sky. As a
result, my energy was focused on the preparations before the balloons took
flight. The saturation of color is high and the texture of the balloon is clearly
rendered. The seam in the balloon and the angle of the man holding the
balloon create visual motion.

Monochromatic Color

A color photograph that is described as being monochromatic uses one color from any part of the spectrum or has the total effect of one color, although different hues are present. The application of a specific color becomes a necessary element of the image. This is the difference between a monochromatic color photograph and one in black-and-white. Although the color is not saturated, this neither lessens its importance nor diminishes its value. It is simply seen and used differently from what we are accustomed to. When other colors are visible, as in the example, they create contrast and add definition.

In this selective application of color, knowledge, understanding, and judgments developed for black-and-white are valuable and necessary.

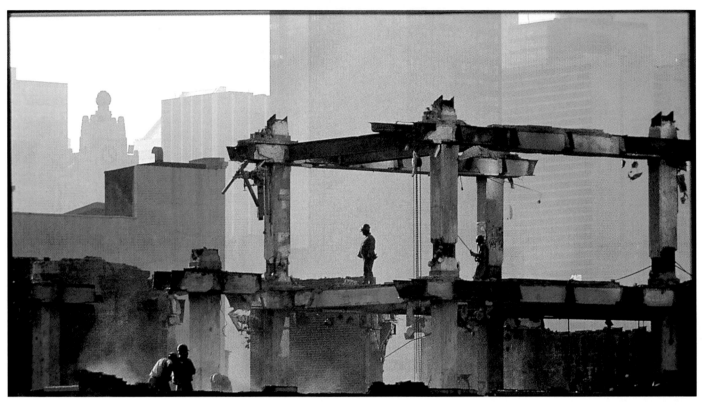

35mm camera, 100mm lens, Kodachrome PKR64

While shooting a job for a client, I went on a rooftop where I observed a construction crew doing demolition. The light was not right for the shot at the time, so I returned in the afternoon. High cirrus clouds filtered the sun, creating a backlit situation that was not harsh.

The brown in the building and workers' clothes are seen throughout this shot. The red in the assorted workers' hard hats moves the eye around the frame. The green of a hard hat and the blue of a worker's clothes on the left are repeated in colors on the wall. The entire background is rendered in shades of gray, but there is a slight reddish brown cast because of the airborne dust. This repeats the color of the building being demolished.

Although the color is not saturated, this neither lessens its importance nor diminishes its value.

Bold Color

When a scene or person is described as being garish or wearing loud clothing, it usually refers to an unusual combination of colors. As eye-catching as the total picture may be, the viewer may experience a certain duality: attraction and repulsion. Dissimilarity creates the attraction. The repulsion may be compared with morbid curiosity. Sometimes color combinations are so striking precisely because of the bad taste exhibited by the person or the scene.

Our day-to-day life in the United States is not filled with rich, contrasting colors. Color is used in a homogenized way that is repetitive and predictable. Amusement parks, nightclubs, and carnivals use color to signal frivolity and define a different experience.

Other cultures and countries use color differently. For instance, in Canada, houses are painted in multiple colors to break the monotony of the white snow and to distinguish one house from another. Vibrant colors are indigenous to the clothing and painting of houses in the Caribbean. A sense of freedom and a carefree quality is often associated with this area, reflected in the bold use of color.

The line between a bold color combination and simple bad taste is a fine one. The photographer must experiment with unusual color combinations.

Color is seen as lacking harmony when saturated color is magnified by strong light-to-dark relationships and tonal contrast. This contrast sharpens the definition of space and color, making them far more vivid.

As you will see in Chapter 5, "Applied Design," shooting an event before it actually begins offers great opportunities. While shooting Carnival in Martinique, I came upon this man hurriedly preparing part of a float for a parade. His bright, multicolored outfit creates a dazzling combination of color against the yellow/gold of the fabric.

35mm camera,
100mm lens,
Kodachrome PKR64

The line between a bold color combination and simple bad taste is a fine one.

35mm camera, 100mm lens, Kodachrome PKR64

Bright yellows and reds of the background contrast with the black
sweat pants and sneakers with the orange laces. The colors are vibrant
and the contrast in tone and hue add to the impact of this shot.

Pastel Color

When a photograph contains different colors similar in shade or saturation, their cumulative effect is passive and gentle. There is a lack of contrast, which results in the blending of the colors into one another. This creates subtle relationships and a luminous quality, because the colors fail to meet sharply, separate, and define each other. Usually early and late daylight and reflected sunlight are responsible for further reducing definition that adds contrast and separation of color.

While we use contrast to define depth, texture, color, size, and so forth, the lack of color contrast can also create a pleasing effect. The blending of colors is an example of the subtlety of the color process. However, it is more difficult for the photographer to develop an eye for a total lack of contrast.

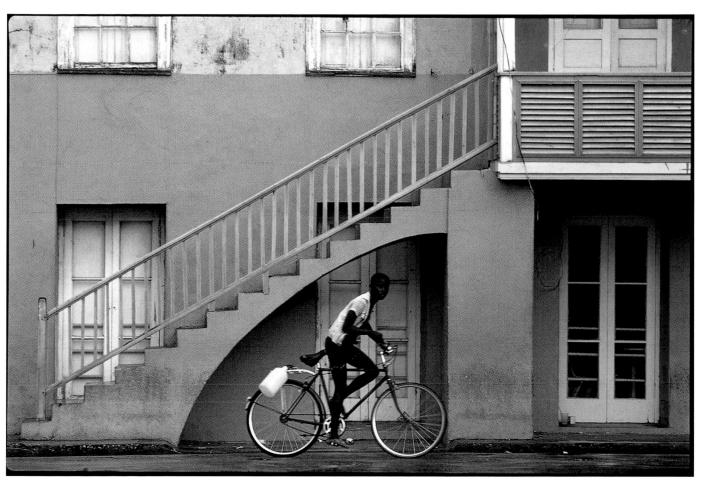

35mm camera, 35mm lens,
Kodachrome PKR64

This was shot very early on a Sunday morning in Barbados. The arrival of this kid on his bike was the element that I needed to make this image work. Given the hour, I did not expect to see anyone and was just about to move on. This photograph is filled with the colors of muted pinks and turquoise. It has a gentle feel to it, even with the contrast of the slightly blurred bicyclist. It is important to note that the kid and the bike are framed by the archway. If the shot had been taken seconds earlier or later, the bike and the kid would have intersected the wall in a way that would have created a degree of tension not compatible with the color combinations.

. . . the lack of color contrast can also create a pleasing effect.

WHERE IS YOUR WORK GOING?

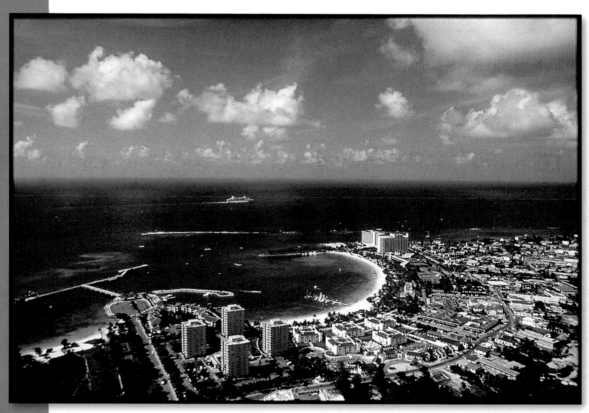

35mm camera, 28mm lens, Kodachrome PKR64

METHODS TO EVALUATE YOUR WORK

Change keeps the eye fresh and the vision uncluttered.

EVENTUALLY, YOU NEED TO ASK THE QUESTION, WHERE IS MY WORK GOING? IT'S NOT an easy question to answer. It is sometimes irrelevant and even counterproductive, but every now and then this kind of reflection can help your creative growth.

Photographers can get into a visual rut, constantly framing images in the same way, which is a major motivation for change. And then, there is simple boredom. No one can shoot the same type of subject all the time. Change keeps the eye fresh and the vision uncluttered. One way to get out of a rut is to look back and study what and why changes took place. Only by looking at the photographs that you have already shot can you define possible future directions.

The focus of this chapter is evolution and change. What causes a photographer to change what he or she shoots? Over the course of my career, I have changed subject matter fairly rapidly. The selected photos in this chapter are organized into chronological order to show the evolution of my work.

I use two different methods to evaluate my work. Every couple of years, I look over my work from the beginning to the present. This provides a general overview of the evolution that has taken place. It allows me to trace the ideas, strengths, ruts, weaknesses, and consistencies in my work over time. This overview doesn't define the future, but it helps to define the present more clearly.

To me, photography . . . generates a response unlike anything else.

The other method is to evaluate the photographs shot over a year's time. They are grouped in three ways: images that work, acceptable images that have not quite hit the mark, and ideas that are good but somehow unresolved. Although it's a similar process to the general overview, the focus is more specific. I look at the first group to establish a frame of reference and to boost my ego. Viewing the acceptable images permits me to identify what I missed and why the images are less powerful than the shots that work. Finally, I look at the unresolved images to analyze what I originally saw in a scene. As a group, these are the most important for forming the basis for future images.

If I am in a visual rut of constantly framing in a similar way, I will be able to realize it and correct it in the future. An unconscious evolution of how I see and what appeals to my eye becomes apparent. A more concise view of where my work is at present and the possible directions for the future is evident. My main concern is the overview and perspective. My eye will go where it wants for now, and I am happy with this approach and accept it.

In contrast to my personal work, my commercial work is clear-cut. Very little conflict is involved. Commercial work has a clear purpose. Therefore, it's easier to answer the question, Where is my work going?

I had a fine arts background and decided to go commercial in New York City. After a year, I decided to move from industrial work and turn my focus to the field of advertising. I made these choices by asking these questions of myself: What challenges do I want? What offers me more growth and uses my talent best in a way that will result in visual expansion? Will this choice allow me to live the lifestyle that I find enjoyable? Will I be working with people whom I enjoy and who broaden my vision by showing me something I had not seen before? I continue to ask myself these questions.

Whenever I pick up a camera, I am aware of electricity that seems to run through me. An inner strength seems to make me quicker, more intuitive, and more aware of what I see. At the same time, a deadening of my awareness filters out anything not relevant to the shot or scene before me. I cross streets and move through crowds with a total lack of conscious thought. To me, photography is a great amusement that generates a response unlike anything else.

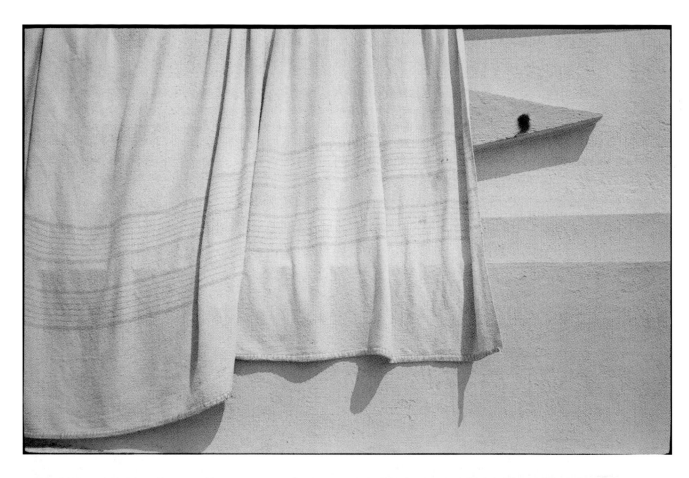

94

CORPORATE

My journey as a fine art photographer began to come to a conclusion when I moved to New York City with my first wife. I believed that if I could be successful as a fine art photographer, then I could do commercial work, even though I had no commercial background whatsoever. I sold my work to commercial clients by saying, "I have exhibited my work all over and of course I can shoot your plastics factory or ad." Amazingly, this approach worked, and I began a career as a corporate photographer. In retrospect, this was a very naïve and bizarre way to have looked at the world of commercial photography. I found a teacher and savior in an assistant named Dennis Connors, who, thankfully, made up for my massive technical deficiency. The skills I developed doing documentary photography were easily applicable to corporate work.

35mm camera, 100mm lens, Kodachrome PKR64

95

35mm camera, 35mm lens, Kodachrome PKR64

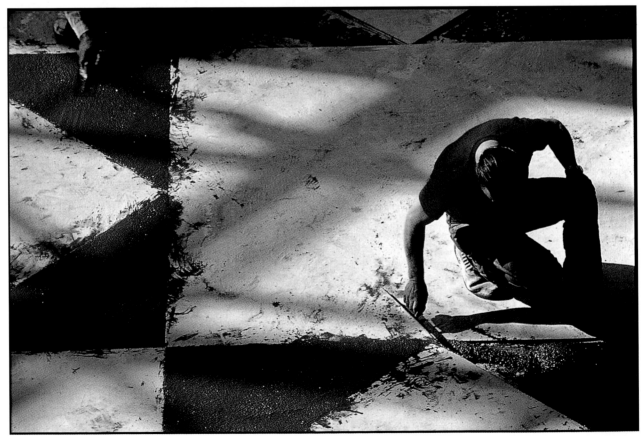

35mm camera, 100mm lens, Kodachrome PKR64

STILL LIFE

My move into the world of still life was really the brainchild of my agent, Elyse Weissberg. She needed a still life shooter and believed that my sense of design could easily apply to advertising. Ultimately, she was right. The money was good, but one factor in the equation I didn't consider was my temperament. I spent days moving fill cards an inch to the left and to the right, and I nearly went stir crazy. Realizing that I was miserable, we parted ways, and I returned to location work. Although I was not happy as a still life photographer, I did refine my ability to use strobes. This knowledge was applied in all my future commercial work.

4 x 5 view camera, 210 mm lens, Ektachrome Professional

YOU SHOULD SEE HOW FRESH WE KEEP A SANDWICH.

Not too many people buy ziploc bags to keep their pets in, but most of our customers have at least one thing in common. They are either trying to keep air out, or moisture in.

Whether it's a goldfish or a tuna sandwich, ziploc has it in the bag.

120mm lens, Ektachrome Professional

EDITORIAL

To build my portfolio with more recent work, I shot not only corpo-
rate, but also editorial work. The speed and pace of editorial shoots
were enjoyable. There was always an unexpected element. I shot
some high-visibility events like the Liberty Centennial. However,
because the work did not pay well, I did this kind of photography for
only a short period.

35mm camera, 400mm lens, Ektachrome Professional

TRAVEL

Of all the different periods in my life—both personal and professional—the time I spent as a travel photographer has been the most enjoyable and gratifying. On the road, I had the opportunity to meet a wide variety of people and learn about their countries and cultures. In one day I ate lunch with a fisherman and had dinner with heads of state.

The production skills that I had acquired as a corporate and editorial photographer were invaluable. I had to call upon the reflexes that I honed by doing documentary and editorial photography. Life was one continuous adventure, filled with the unexpected, and I had a great time.

35mm camera,
24mm lens
Kodachrome PKR64

35mm camera,
100 mm lens,
Kodachrome PKR64

APPLIED DESIGN

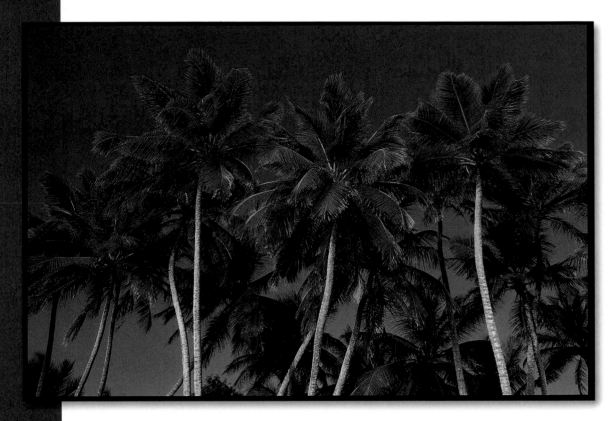

35mm camera, 24mm lens, Kodachrome PKR64

TECHNIQUES FOR GETTING THE SHOT

The key is to understand what goes into getting the shot.

THERE IS NEVER A GOOD REASON FOR CREATING A POORLY DESIGNED PHOTOGRAPH. However, when you shoot something new and unfamiliar, the problem-solving process itself can get in the way of creating good photographs. For example, the skills you developed to shoot landscapes may not work for events, such as a parade. This chapter introduces techniques for shooting unfamiliar subjects. The key is to understand what goes into getting the shot. You can use these techniques to shoot a wide variety of subjects. As you look at the photographs in this chapter, you will realize that there are similar approaches used in shooting dissimilar subjects.

...you need to focus on what is in front of your lens and simultaneously be aware of your surroundings.

The first thing you must learn is that, regardless of subject matter, you need to focus on what is in front of your lens and simultaneously be aware of your surroundings. When I shoot an event, all action around me ceases. Yet at the same time I am aware of anything new that enters the frame. The one thing that should not affect your shot is your emotions. If you feel hungry, tired, cold, angry, frustrated, or disappointed after a long day of shooting, try to ignore it. Such feelings are not relevant to the shot. Try to shut out all emotions as you push the shutter down. Being emotional while shooting can only result in mediocre photographs.

You will find that most of the topics covered in this chapter rely heavily on the exercises covered in Chapter 2, "Look Before You See." Sports photography, for example, relies heavily on the concepts of having an instant response and waiting for the moment. There is a very simple equation in photography, namely, the more you shoot, the more you will learn.

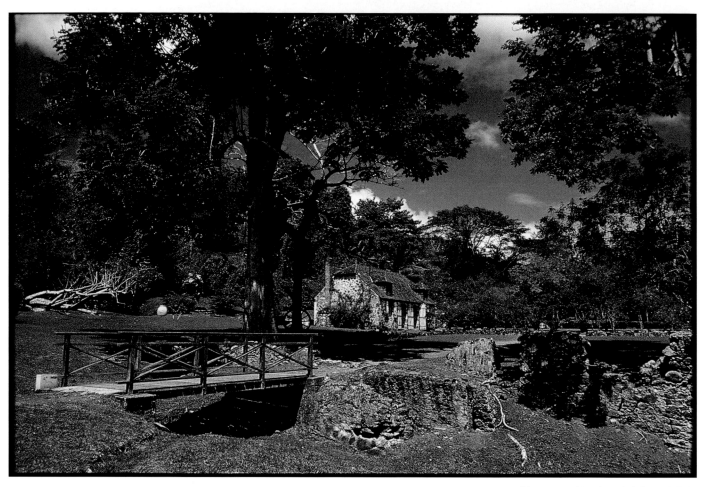

35mm camera, 24mm lens, Kodachrome PKR64

On the island of Martinique stands a building that was once the home of Josephine, wife of Napoleon Bonaparte. The only structure that actually remains is the original cooking house. Shooting it in the context of its surroundings communicates the beauty of the island and makes it more visually appealing. I had to return to this location a total of four times before the light and sky were right.

As you travel, it's important to ask locals where they go and what they think best shows the beauty of their country.

This widely published photograph was shot on location on St. John. It was shot after 10 AM, when the clarity and beauty of the water would show clearly on film. The clouds and the deep blue sky act as counterpoints to the water below. It is interesting to me that when I show women this shot, their reaction is always that they could see themselves there. Men, on the other hand, only see my wife Amie in the water. Regardless of the viewer's first impression, it is ultimately the sheer beauty of the island that leaves its mark.

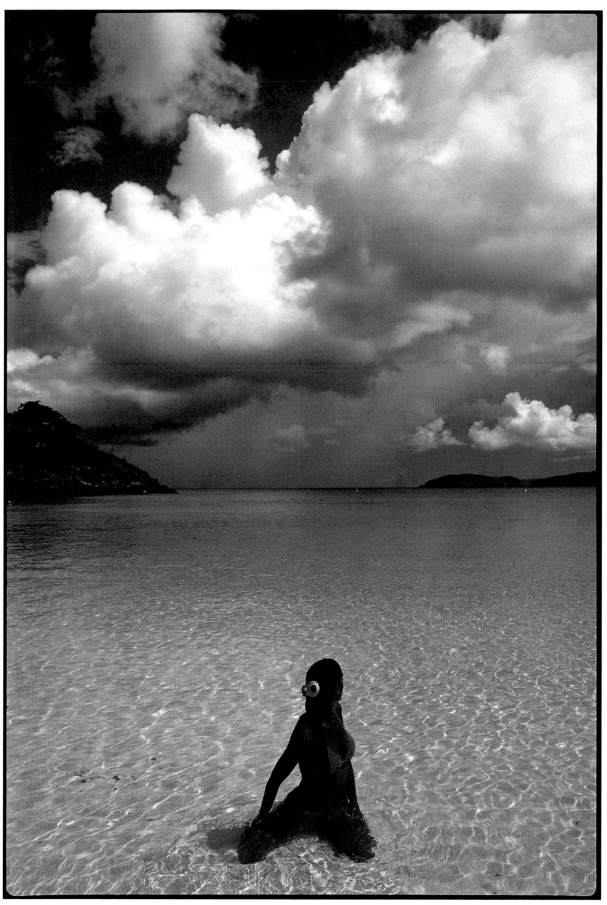

35mm camera, 24mm lens Kodachrome PKR64

PORTRAITS
CONNECT WITH YOUR SUBJECT

Portraiture is a very broad subject to cover, so I will focus on editorial and advertising portraits shot on location. There are really two ways to shoot an editorial portrait. One way is to show people as they see themselves. This approach is suitable for weddings and photographs of family members. The other way is to photograph them as they really look to the world (see the shot from Carnival). Commercial photography, specifically advertising, involves the posing of models to sell a product. This kind of portrait is inherently staged.

The key to shooting any portrait is to make some sort of connection with your subject from the beginning. Watch how they stand and assess whether they are comfortable or not in front of a lens. If they are uncomfortable, you have to find a way to either make them comfortable or distract their attention as you shoot. When shooting, I always look at my subject with the camera away from my eye so that he

or she can look me in the eye. A camera in front of your face inhibits communication with your subject and can make the person more self-conscious. If it is a staged shot, where you can tell someone to straighten a tie or tuck in a blouse, it is your responsibility to see and correct any errors before the shot is made. Look at your subject's face and identify the best angle to shoot. Most women will point out their better side and most men will be mute.

Do not make the most common error of letting your emotions affect you. If you are not objective when you look through the lens, the photograph will not communicate what you see with your heart and mind. Finally whenever possible shoot more frames of film than you need. Usually it is that one moment where an eyebrow is raised or a smile looks genuine that is the difference between a good portrait and a great one.

35mm camera, 100mm lens, Kodachrome PKR64

There are times when finding the location is the hardest part of a shoot. It certainly was the case for this ad, taken for Paramins, a division of Exxon. The ad agency, Brushfire, and the client wanted the background to be filled by a truck engine, since that was what the product was for. I was working with Allencrest Locations, which, by being tenacious and persistent, found a truck-and-engine repair shop that would allow us to come in and shoot. After the location had been scouted, a casting was done and the two models were selected. On the day of the shoot, my assistants and I showed up on location a couple of hours prior to the arrival of the Senior Art Director, John Woldin, and the account executive. By the time they arrived, the lighting was already set up. Black seamless was placed behind the engine to eliminate distractions from the models and the engine. Once the models arrived and changed, all that was left to do was shoot.

A good model is one who understands what is being shot and the role that he or she is to play. Both of these guys were pros and required direction only for the variations in body and hand positions. The key when shooting advertising is to shoot variations that the agency can then bring back to the client. The shot of the clean piston was not selected. It was felt by agency and client alike that the shot of the dirty piston better highlighted the problem that the Paramins product prevented.

The key to shooting any portrait is to make some sort of connection with your subject from the beginning.

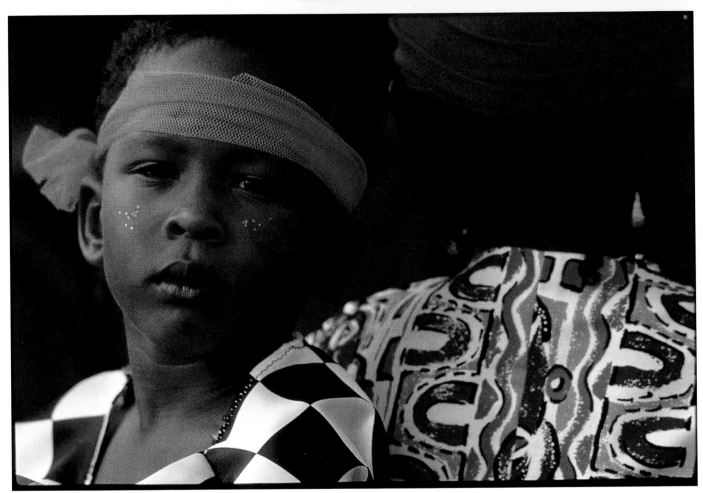

35mm camera, 100mm lens,
Kodachrome PKR64

This shot, taken during Carnival in Martinique, is an example of waiting for the moment. While shooting the parade, I spotted this boy and his sister sitting under a tree watching the festivities. The bright colors and skin tone were what caught my eye. The obvious shot would have been the two faces side by side. However, I stood with camera away from my eye and waited. Suddenly, as a band began to play behind them, the girl turned around. The image was now complete.

There are two important points to remember. First, when shooting a portrait, know what you are seeing and ask yourself if there are other possibilities. Sometimes you create possibilities by asking people to move, adjust a sleeve, turn left. At other times, as in this shot, you wait for the unexpected. Second, most people are uncomfortable having a camera pointed at them. When shooting a portrait, I always raise my head above the camera. I look directly at the subject or talk to the subject and shoot at the same time. Many kids are far more receptive and less intimidated by this approach.

SPORTS
ANTICIPATE THE ACTION

There is a huge difference between shooting sports for advertising purposes and for editorial purposes. Simply, the difference lies in the amount of pre-production time and money spent capturing one moment on film.

For a commercial shoot, preproduction includes scouting out locations, buying insurance, and hiring models. Once the camera is set and the Polaroids are approved, the athletes have to repeat their actions over and over and over until the shot is in the can. For example, I have had pole vaulters go over the bar twenty times and runners sprint up to a finish line ten times as camera angles and lenses were changed. Instead of waiting for the moment, as is the case in editorial sports photography, commercial shoots call for creating the moment.

When you shoot sports for editorial purposes or for yourself, there is little preproduction involved. If you are shooting a game that you know, the first step is to find the best vantage, with the best lighting. Telephoto lenses will usually allow you to fill the frame with the players. The key is to watch the game and anticipate the action. There

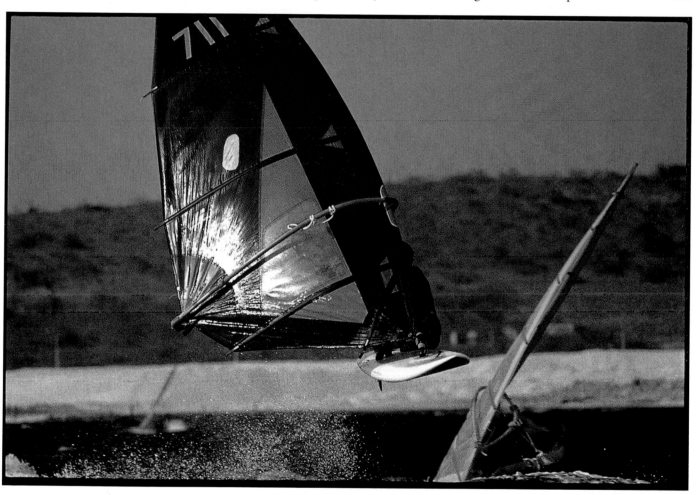

35mm camera, 400mm lens, Kodachrome PKR64

One of the most popular sports in Curaçao is windsurfing. Constant trade winds insure good windsurfing year-round. Having never shot this sport, I did a little preproduction before going down there. I arranged to have a boat bring me out into the best area for windsurfing. Knowing that I was going to be bobbing and bouncing around in a little boat, I rented a gyrostabilizer. Initially, I just watched as the windsurfers flew back and forth, to get an idea of the direction of their movements. After two runs, the rhythm and course of the windsurfers were clear to me. While a motor drive is great to use for this kind of shoot, you still have to anticipate the action and catch it at its peak.

is no magic solution for this kind of shoot aside from patience, anticipation, and quick reflexes. When you shoot a sport that you are unfamiliar with or have never shot before, the first thing to do is to watch the game. Get a feel for the ebb and flow, player motion, and direction of movement. As you watch, move around the field to find a good spot to shoot from. As is the case with an event, the beginning and end of the game offer excellent shooting opportunities. With action shots, the key is to get the athletes at the peak of their motion—for instance, a batter as he connects with a ball or a runner as she crosses the finish line. Sports photography is difficult and requires patience and practice.

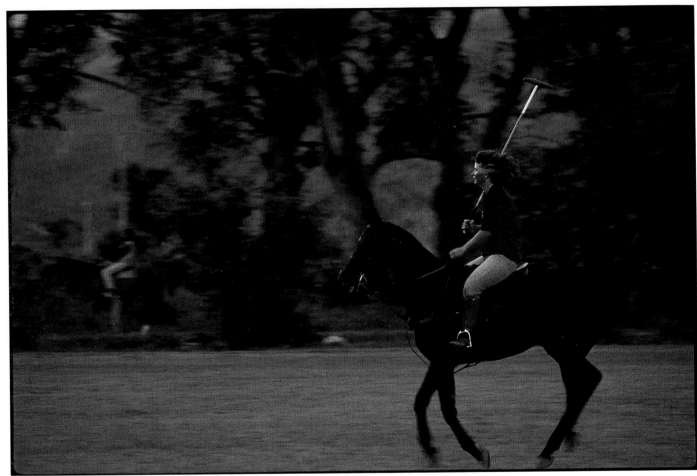

35mm camera, 200mm lens, Kodachrome PKR64

When I was on assignment in Jamaica, photographs of polo were on the shoot list. However, there was a mix-up in communication and were no games scheduled for two weeks. My alternative was to shoot a scrimmage, which seemed good to me. Heavy rains made the usual field unusable, so the scrimmage moved up in the mountains late in the day. The situation, location, and light were not what we had planned for, but the bottom line was that I needed to get something good on film. Since I was unfamiliar with the game, I watched as horses and riders zipped up and down the field. Using a long lens and slight pan, I was able to communicate the feel of the game's motion.

When you shoot a sport that you are unfamiliar with or have never shot before, the first thing to do is to watch the game.

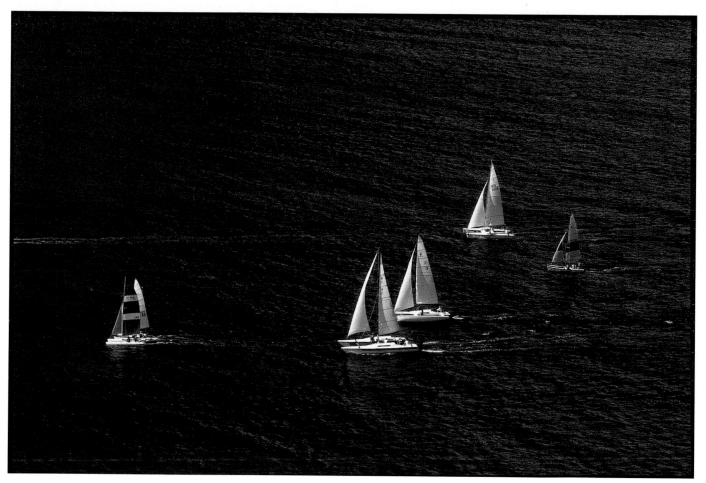

35mm camera, 200mm lens, Kodachrome PKR64

Shooting a sailboat race with no prior experience requires the ability to make sound and quick decisions. It's best to shoot such a race above the action, as was the case in this shot, or to ride on the boat itself. Shooting the race from ground level would yield unimpressive results. I had previously scouted this area on St. Martin for a cruise ship shoot and had found an excellent vantage high above the harbor. we jumped in the car, went up to the location, and waited for the boats to leave the harbor. A long lens allowed me to isolate a few boats and to communicate a feel for the sport of sailing.

35mm camera, 200mm lens, Kodachrome PKR64

Golf is a sport that I do not play. On location in St. Croix, in the U.S. Virgin Islands, we scouted out two courses before finding the perfect location. The shot had to communicate not only the game but also the Caribbean location. After watching a series of strangely attired golfers play, I was rewarded when this couple arrived in front of my lens.

- In commercial photography, create the moment.

- In editorial photography, wait for the moment.

- Watch the game and anticipate the action.

- Get a feel for the game's ebb and flow, player motion, and direction of movement.

- Capture the athletes at the peak of their motion.

EVENTS
MOVE THROUGH THE CROWD

Festivals and parades are the most common events people photograph, yet such events are among the most challenging subjects to shoot. From experience I have found that the best times to shoot are before and during the start of an event and at the end of the event. While moving continuously during an event, I constantly look for shots and watch the crowds. Again, preproduction is very important. Before the event, find out where it begins and ends. If you are unfamiliar with the area, scout it out beforehand.

I prefer using two cameras, with a 28mm lens on one and either a 100mm macro or 200mm lens on the other. I keep my camera bag light and small, with just three to four lenses, so that I can move freely through the crowds and not get tired from its weight. Usually I use one speed of film, and lots of it. Since I am walking and on my feet continuously, I wear sneakers and comfortable clothes.

In many ways, shooting an event is an endurance contest. If the event begins at 9 AM, you have to arrive at 7:30 and watch and shoot as the setup process unfolds. If the event is a parade, and it ends at 1 PM, get to the place where the parade ends by noon. In between, walk the route and shoot not only the participants but the crowd as well. At some point, take a break away from the crowds and noise and rest. This is necessary, to recharge your body as well as your mind and eye. These three shots, from the New York Mets World Series parade, present some options available to you when shooting an event.

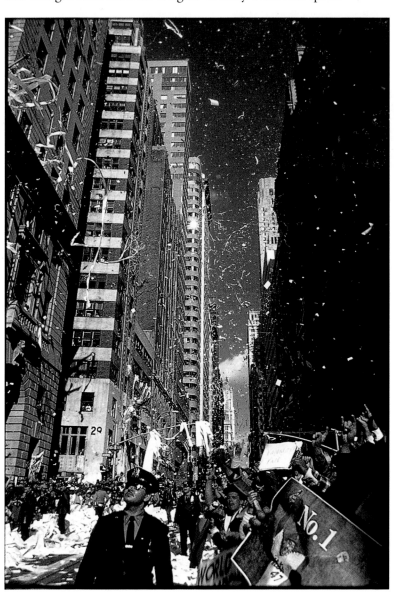

To get this shot, I worked my way through the crowd to be at the police barrier. A float had passed by and the crowd was waiting with anticipation for the next float to wind its way up the street. Raised hands coupled with flying confetti communicate the excitement of the parade.

28mm lens,
Kodachrome PKR64

- Scout out an unfamiliar area before the event.
- Carry a light bag, with just three to four lenses.
- Arrive well before the start of the event and shoot the setup process.
- Shoot the crowd, as well as the participants.
- Take breaks from the crowds and noise.
- Wear sneakers and comfortable clothes.

35mm camera, 200mm lens, Kodachrome PKR64

Watching and shooting the crowd is an integral part of shooting an event. Watching as the confetti fell on the spectators, I had not seen the shot that I wanted. Finally, office workers above started unraveling reams of computer paper and tossing it down on the spectators below.

While moving continuously during an event, I constantly look for shots and watch the crowds.

After an event has ended, there is the opportunity to get a shot that gives perspective to what has just occurred. In this shot, the parade had just passed this part of the crowd, and they had begun to disperse. A floor of confetti, with a confetti-covered tree shows the scale of the event that has just ended.

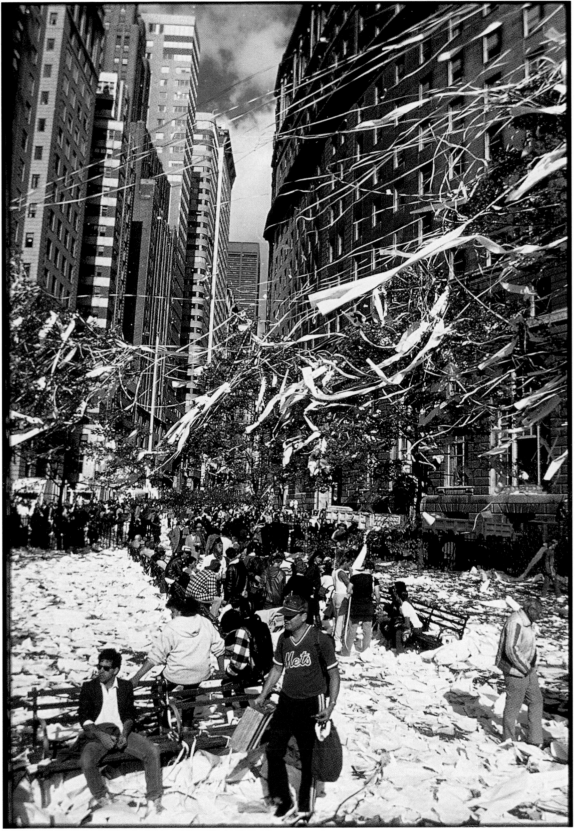

35mm camera, 24mm lens, Kodachrome PKR64

EXTERIORS
START WITH THE RIGHT ANGLE

Whether you are shooting residential or commercial exteriors, the process is pretty straightforward. The two most important factors are angle and ambient light. The shooting angle will determine the choice of lens. How the sun's rays hit the building will determine when to shoot. When possible, I prefer to scout the location first. Many times because of distance, this is not possible, so I rely on a job superintendent to relay this information over the phone.

Since there is usually only a small time frame when the light is perfect, shooting exteriors requires a lot of patience. Most of the time is spent waiting for the sun and clouds to be just right. The only other real but necessary way to spend the time is to scour the scene and remove any garbage, dead flowers, and leaves. As I wait for the light, I have found that newspapers and a cell phone are great companions to have along to pass the time.

35mm camera, 20mm lens, Ektachrome E100VS

- Let the angle of the shot determine which lens to use.

- See how light hits the building.

- Wait for the best light.

- Prepare the scene by removing unwanted clutter.

The key to shooting exteriors, as stated before, is perfect light. However, when a building faces north, the sun doesn't hit the front of the building. Therefore, you are left with shooting either a dusk or a dawn shot. This rear exterior of a clubhouse shot for Renaissance/Calton was shot at dusk because it faced north. While shooting interiors, we watched the sun set. My assistant, Tina, and I ran out to set up the camera and waited for the sky to balance with the lights in the building. Ten minutes later, this was the result.

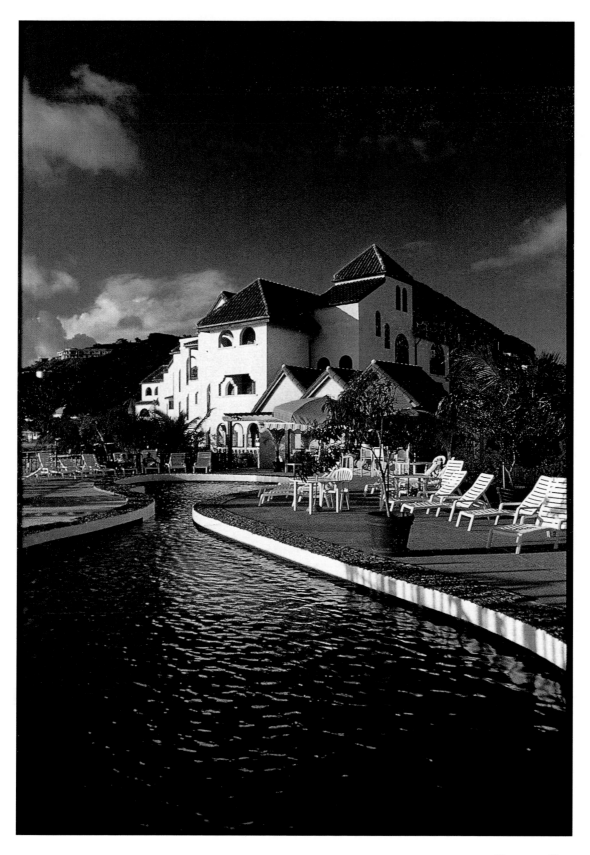

The sale of time-shares all over the world has become a huge business. In St. Martin, for client Divi Hotels, patience while waiting for the light and clouds to be right was the only thing that this shot required.

35mm camera, 24mm lens, Kodachrome PKR64

35mm camera, 35mm lens, Kodachrome PKR64

One way of shooting a cityscape is to contrast the old against the new, or the beautiful against the ugly. On location in Buffalo, New York, for an investment-banking firm, I took this shot atop a neighboring building.

Since there is usually only a small time frame when the light is perfect, shooting exteriors requires a lot of patience.

INTERIORS
CHOOSE A STYLE

Photographing interiors and doing it well takes time, practice, and patience. To me, there are two styles of shooting interiors, and it is really a matter of taste as to which is more appealing. One is what I call the *Architectural Digest* style, which is very studied, architecturally oriented and, in terms of visual and emotional quality, kind of cold. The other approach mixes incandescent light with strobes and available light. As a result it is warmer and to me more accessible to the viewer. I shoot in both styles, the first for commercial clients and the second for advertising and residential clients. I prefer a warmer look and feel to an interior photograph. This topic could easily fill a book, but here are some important points to get you started.

When you shoot an interior consider a number of points. What angle best shows the room both architecturally and aesthetically? Where and how am I going to light this? Should I include ambient and incandescent lights? What is the best time of day to shoot? In terms of exposure, do I want the view to be visible or washed out? Are there dead spots in the scene? Does the scene have to be styled or can I simply move some plants and furniture around? Shooting interiors takes care and thought. However, you do have the luxury of knowing that your subject will not get bored by your presence and get up to leave.

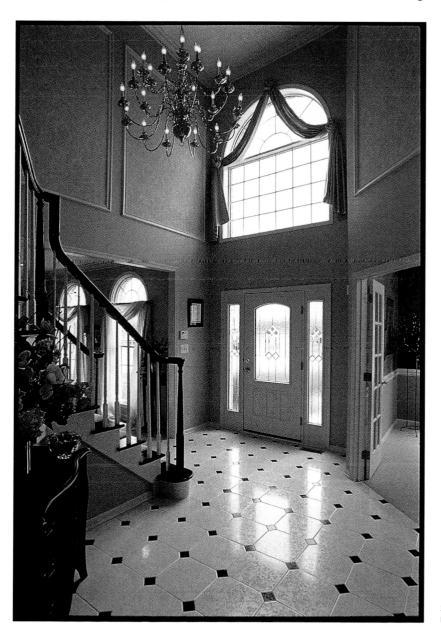

- Choose an angle that shows the room architecturally and aesthetically.

- Decide how to light the room, and whether to include ambient and incandescent lights.

- Decide whether to include the view through the window.

- Decide whether to style the room.

- Choose your camera format.

Typically when a shot of a foyer is taken, it is shot from the front door looking inward. This image created for Calton Homes was a departure from the norm. Shooting it from this direction and seeing into the other two rooms enhance the grandeur and elegance of the main entryway.

35mm camera, 24mm lens,
Ektachrome E100VS

Sometimes, there can be a problem shooting the view outside a window, such as unwanted construction, trucks, and so on. The easiest solution is to shoot at night. However, this means shooting without the benefit of natural light. The other option is to use a long exposure (1/2–1/15 a second) to blow out the details of the scene outside. Even with this approach some detail will be visible. The third option is time consuming and impractical on really huge windows. This is to put a translucent material, called scrim, over the window. Two kinds of scrim, Lumalux and Tough Spun, are available. I prefer the Tough Spun because it lets in more light and the diffusion of light is softer. This material is very expensive and is useless if it gets dirty or ages from use. However, the results are well worth the time and cost. The example that follows shows the effect of using scrim without direct sunlight.

In terms of format choice, your client and your personal preference dictate this decision. Most photographers use either a 4 x 5 camera or a 2¼ to shoot interiors. While I do use a 2¼, I personally prefer a 35mm camera for a couple of reasons. First, I love the 20mm lens, which has a wider angle of view than any other format. Second, most of the time I am shooting a large number of shots in a day and the 35mm is faster to work with. Finally, the changes in technology regarding film and scanning make it nearly impossible to distinguish between a shot done with a 35mm or medium format.

35mm camera, 20mm lens, Kodachrome PKR64

Sometimes, how you shoot a subject is dictated by the client. This commercial interior was shot for an investment banking firm in New York City, using a combination of strobe and available light. This shot really relies on the balance, in terms of exposure values, between the incandescent lights of the interior and the available light from outside. CC gels over the camera lens corrected for the interior lights, and the available light is rendered a little blue.

*I prefer a warmer look and feel
to an interior photograph.*

35mm camera, 20mm lens, Ektachrome E100VS

The hardest interiors to shoot are those that are small and have low ceilings. Control of light is made more difficult and more time consuming. This image created for Renaissance/Calton is a second-floor loft. It was lit with four heads and a small amount of available light from windows not seen on the left side. I used the widest lens available without linear distortion to make the room appear much larger than it really is.

35mm camera, 20mm lens, Ektachrome E100VS

When you are shooting interiors, you have to decide how the world outside the windows will be rendered on film. In this shot, created for a client, Roseland Property, seeing the New York City skyline in the background was critical, because the properties were being rented or sold on the basis of their proximity to the city. I adjusted power on the strobes until a balance of exposure was created, so that both interior and exterior were visible.

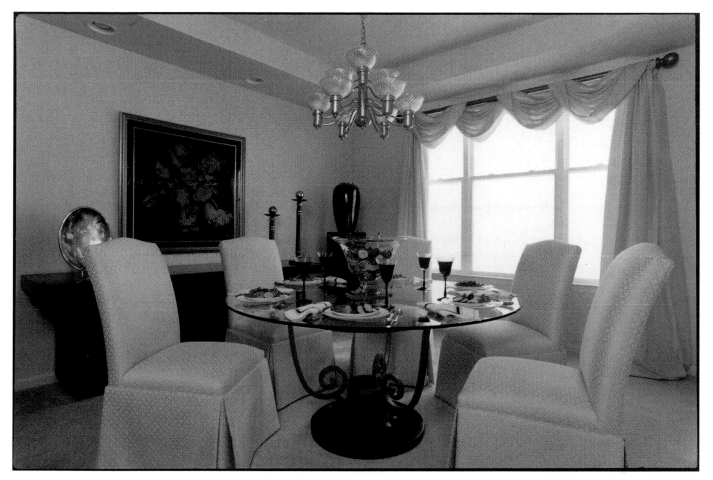

35mm camera, 20mm lens, Ektachrome E100VS

White on white is probably one of the most difficult things for a photographer to shoot. To get a good result, there had to be a soft balance between the light from the window and the strobes inside. Shot for client Robertson Douglas, this image shows the effect of indirect sunlight and scrim. Using an exposure of 1/8-second, the light is evident and very diffused. One flash head bounced off the ceiling acts more as a fill light. An interior designer styled the shot with a minimalist approach, adding red wine and tomatoes to add a splash of color, which makes the shot effective.

WORKING WITH A STYLIST

Of all the people that I hire to work with me on a shoot, it is the stylist who can really make or break a shot. Assistants, models, hairdo and makeup people are all critical, but it is the stylist's role and input that makes the shot. Simply, the stylist is the person who shops for clothes, props, food, and so forth. These are then placed in the setup to be photographed. First, the stylist meets me at the location and goes over all things needed to do the shot. The stylist then spends a day or more shopping for the necessary items. A good stylist is a good listener who is confident of his or her vision, can add ideas that the photographer did not consider, and honestly loves to shop. On the day of the shoot,

it is the stylist who makes certain that the clothes hang just right and lays out the props in the right position.

For the photographer the stylist adds one critical element, and that is another set of eyes to view the shot. Most stylists look through the camera, tweaking and moving all of the little elements in the scene to make it look perfect. A good stylist, like a good assistant, is part of the photographer's team. If, as a photographer, your goal and responsibility is to create the best shot possible, it is very important to listen to the ideas of the people that you hire. This does not mean that your stylist will always be right, but you did hire them for a reason.

35mm camera, 20mm lens,
Kodachrome PKR64

For this shot, interior designer Fran Tessler, acted as stylist as well. Photographed for client Renaissance/Calton Homes, this image is not exactly what it appears to be. It illustrates one of the main problems when photographing new home construction. Outside the windows of these decorated models were other houses under construction. The view through these windows was of a golf course being built. Actually, it was Fran's assistant who came up with the idea of chopping down trees and staking them into the ground. The trees we used were going to be knocked down anyway. Again, I bounced a flash head off the ceiling to enhance the ambient light. The result was very effective and no one could spot our camouflage work. The beauty of the room is all that the eye sees.

35mm camera, 20mm lens Kodachrome PKR64

This image, also made for Calton Homes, was designed and styled by Fran Tessler. Here the role of the stylist was very important to the shot. Fran selected and bought all the necessary props, including food, fruit, and flowers. She prepared and arranged them and laid everything out on the tables and counters. Constantly looking through the lens, she had props moved, turned, and removed until we were both satisfied with the final result. When I shoot interior photographs, I want people to feel as if somebody has either just left the room or is about to enter.

- A good stylist gives input that contributes to a shot.

- A stylist acts as another set of eyes to assess a shot.

- Listen to the ideas of the people who you hire.

A good stylist is a good listener who is confident of his or her vision, can add ideas that the photographer did not consider, . . .

SCENICS
WAIT FOR THE LIGHT

When it comes to landscapes and cityscapes, there are two vital elements: perfect light and the angle of the shot. For a professional, it means scouting the location beforehand and knowing a general time frame for when the light will be right and the best angle or vantage point. Get to the location a minimum of an hour or so before the light is expected to be right, framing the shot and waiting for sun and clouds to be perfect. Photographers on location spend a lot of time waiting for the sun and clouds to be perfect. If for any reason I believe that the light is perfect, I shoot the shot and then I see how the movement of the sun changes the scene before me. I stay until I can see the light is no longer good. A great image makes it all worthwhile.

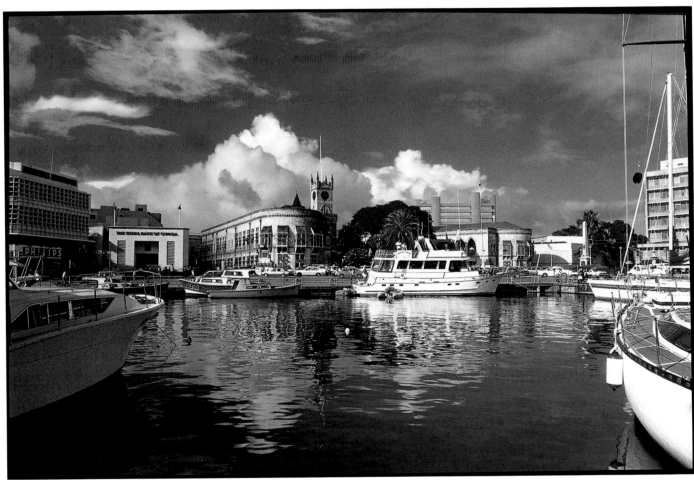

35mm camera, 35mm lens, Kodachrome PKR64

The key to this shot was the light, sky, and vantage point from which it was shot. I needed to get a photograph of Bridgetown, capital of Barbados, one that would show the city and its location on the water's edge. The first two times that I came to do this shot, the sky wasn't right, but the third time worked like a charm.

Photographers on location spend a lot of time waiting for the sun and clouds to be perfect.

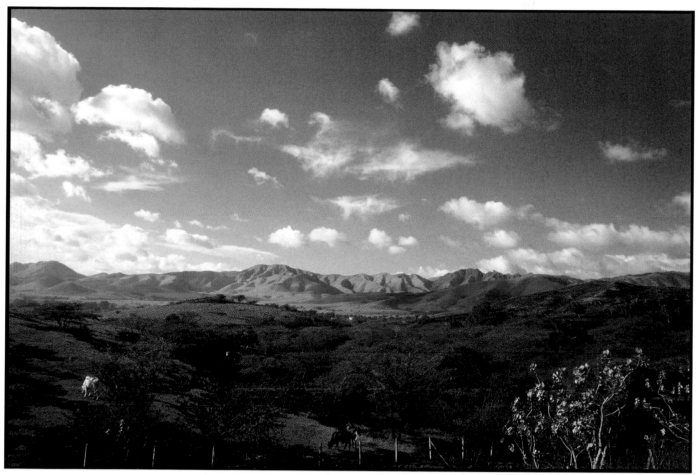

35mm camera, 28mm lens, Kodachrome PKR64

In Puerto Rico, there is a highway that connects Old San Juan to the city of Ponce. As we drove along, we stopped for shots that looked promising. After leaving the mountains and rain behind, we came upon this arid scene. It was the dramatic change in scenery that made me stop the car, get out, and shoot. As you drive along, whether on business or on vacation, stopping to shoot can produce some really nice surprises.

- Scout the location.

- Know when there will be the best light.

- Find the best angle and vantage point.

- Get to the location at least one hour before optimum light.

131

ADVERTISING THE PRODUCT ON LOCATION
WORK WITH A TEAM

Photographing a product on location for advertising is a very time consuming and demanding venture. Starting with the art director's layout, the next step is to find the perfect location. I use a company that identifies locations and does scouting, as well. The art director, scout, and sometimes the production manager go with me to see three to four choices. When the final location is selected, the next step is to determine the lighting and styling of the shot. At this point, there are meetings with a stylist to determine what props are needed. If models are to be included, a casting must be done and a model selected by the art director and client. When a shoot is on location, a fee is paid to the owner. In addition, a separate insurance binder or certificate of insurance must be issued and presented to the property owner on the day of the shoot.

The final step is the shoot itself. Two to six assistants move the furniture and insert the props. After the lighting is refined, the models dressed, and myriad different changes made, the photography begins and ends within forty-five minutes. For an advertising or product shoot on location to be successful, the prerequisites are thorough preproduction, a sense of calm, and a sense of humor. The unexpected problems that always come up when on location have to be dealt with in stride.

Since absolutely every detail matters, it is the responsibility of the photographer to oversee everything, no matter how trusted and experienced the crew is. This kind of shoot is obviously not for the short-tempered photographer, nor is it for the photographer who feels that everything must be under control at all times. From this controlled chaos can emerge an image that sells the product and, ideally, exceeds the art director and the client's expectations. Good communication and rapport with the art director and your crew are the keys to making this kind of shoot move smoothly.

35mm camera,
20mm lens,
Ektachrome E100VS

Sometimes a product needs to be shot on location to illustrate how consumers use it. Porcelanosa, a Spanish manufacturer of tile, stone, and marble, wanted to show the variety of products in use by various builders. This shot taken on location at a project of K. Hovnanian was very challenging. It seems simple to combine window light with a strobe head bounced into the ceiling. However, the bathroom was so small that I had to hand-hold the camer, and controlling bounce light was arduous. The exposure of the strobe was balanced to allow the blue sky to be visible.

Antique Treasures. Because beauty comes with age.

For 70 years Couristan has combined timeless beauty with expert craftsmanship. Presenting Antique Treasures, a collection of 100% wool hand-knotted rugs. Designs to treasure for a lifetime. For a free color brochure call 1-800-WE-LUV-RUGS (935-8878) ext. 569. Pictured: Chi Chi Design in Gold.

COURISTAN®
The foundation of any great room.
Two Executive Drive, Fort Lee, NJ 07024

Allencrest Locations, a location scout firm, found this spectacular home. After five possible locations were submitted to Creative Director Larry Mahurter of Couristan, the final selection was narrowed down to three houses. Judy Sillen of Allencrest, Larry, and I then visited all three locations, and Larry decided on the house used in this photograph. This location was selected because the room was perfect for the carpet, the existing furniture and accessories worked well together, the view overlooking the river was perfect, and finally there were other rooms in the house where we could shoot other rugs. We worked with three assistants and a stylist. The room was arranged, and the rug was laid down.

35mm camera,
20mm lens,
Ektachrome E100

For an advertising or product shoot on location to be successful, the prerequisites are thorough preproduction, a sense of calm, and a sense of humor.

- A team can include the photographer, an art director, models, a production manager, a stylist, and two to six assistants.

- Do thorough pre-production work.

- Be patient and have a sense of humor.

2¼ camera,
40mm lens,
Ektachrome E100VS

This shot, taken for the agency Gianettino and Meredith and for the client Samsung, is a perfect example of how the product (the microwave), though small in size, is the focus of the ad. In advertising, it is the total ad that matters: the marriage of concept, headline, body copy, and photograph working as one to sell the product by creating a need or lasting image in the consumer's mind.

The location was the most important element in the shot. At first we considered residential interiors, but they did not have all the right appliances or look to them. The stylist, Amie, suggested kitchen and bath showrooms, and Judy Sillen of Allencrest Locations found the site that satisfied both agency and client. The model was selected and the stylist searched for the right props. Arriving early, we started to set up the lighting. Creative Director Rich Palatini arrived. Props were selected and placed in the setup. Once the model arrived, additional clothes were purchased, along with real food. Now we were ready to shoot. Total shoot time was only 20 minutes. Preproduction, including scouting, casting, and lighting, and postproduction, such as breaking down the set down, took three days. The ceiling has been added through retouching.

AERIALS
SHOOTING FROM THE AIR

Aerial photography offers a unique way to see the world. Aerials are shot from an airplane or, more likely, from a helicopter. When doing commercial aerials, there are a number of steps that I take before I even get in the helicopter. Usually I am given a shoot list, which includes descriptions of what needs to be shot. I also require a site map detailing the exact location, with landmarks on it to facilitate identifying the subject from the air. I also need to know which direction it faces to determine time of day for the shoot.

Since I do aerial shots on a regular basis, I can point out some potential problems and solutions. One problem is vibration from the helicopter. For amateurs and professionals, the norm is to shoot at either 1/500 or 1/1000 of

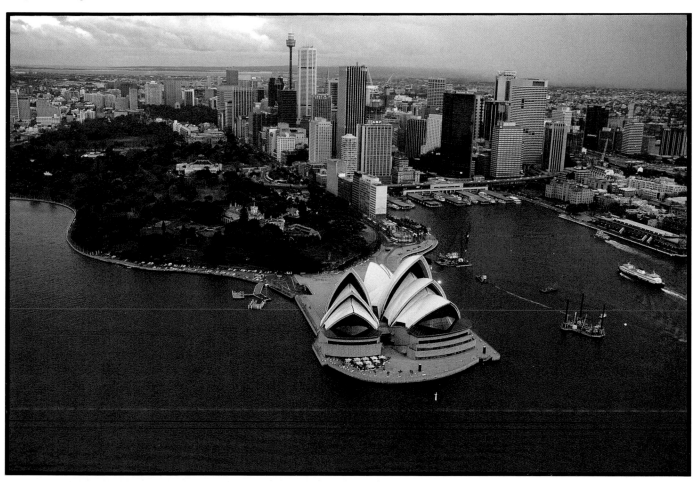

35mm camera, 28mm lens, Ektachrome
pushed to 800, 1-second exposure

If you shoot a lot of aerials, you can go to unusual locations. Senior Art Director Jeff Yates and I flew to Australia from New York City for one day to shoot the Sydney Opera House. Before departure, I had to rent a gyrostabilizer, hire a pilot, and make arrangements to have the lights turned on for the Opera House just before dusk. Also, we were required to get a work visa just to do this one shot. Thirty hours and twelve time zones later, we arrived in Australia. We were so exhausted that we fell asleep in the middle of a gourmet meal. The next day we went to the Opera House to pay them a usage fee and to confirm that the lights would be turned on before dusk. As luck would have it, the late afternoon was filled with rains squalls and 35- to 40-knot wind gusts.

As dusk approached, we watched in dismay, as the lights did not go on. Finally, after several phone calls, I stood out on the pontoons and began shooting. The final exposure was 1 second with pushed film. At 4 AM the next day, we were on our way to a shoot in Hawaii.

a second to avoid camera vibration from the helicopter. Another option is to use a gyrostabilizer for the shoot. These can be rented. Two gyros rotate at a very high rate of speed and effectively absorb the vibration. Heavy and awkward to use, the gyrostabilizer has allowed me to shoot at 1-second exposures.

Another issue to consider is whether to shoot out of the helicopter through an open window. You can also remove the door and stand out on the pontoons, while attached to the helicopter via a safety harness. I prefer to stand outside the helicopter because it gives me more flexibility in viewing angle. Unless you are being paid a lot of money, I would suggest that you avoid doing this. Standing on the same side of the helicopter as the pilot makes it easier to direct him or her.

Aerial photography presents the photographer with the problems of having to communicate with the pilot while concentrating on getting the shot. This kind of shooting is done well by few people because there is so much going on at once.

Finally, for some people, there is the problem of height. I must admit that I really hate heights and normally would not enjoy this kind of shooting. However, as soon as I put the camera up to my eye and the world becomes two-dimensional again, my discomfort immediately vanishes. So if you do go up on a helicopter, try it with your camera in hand. This may also alleviate the airsickness some of my clients who have insisted on coming up with me have suffered.

35mm camera, 200mm lens, Kodak Royal Gold 100

Be aware and understand what your client needs from a shoot. When you are simultaneously guiding a pilot and looking for locations from the air, it is still imperative to remember that your client's needs are the only reason why you are shooting in the first place. On this shoot for Schoor DePalma, we covered residential communities for which they had done the engineering. With only a few houses, this image represents a residential community. Note how the inclusion of the red car makes the image complete.

I prefer to stand outside the helicopter because it gives me more flexibility in terms of angle of view.

35mm camera, 100mm lens, Ektachrome E100VS

One of the great aspects to doing aerials is that there are always opportunities to shoot pictures for yourself as you are traveling to and from the locations that are on your shoot list. The key is to have your cameras and eyes ready. To get the images you want, you need to anticipate the shot and have quick reflexes. Look ahead, through the windshield, to find potential shots.

- Get a site map, with landmarks to identify the subject from the air.

- Determine what time of day to shoot.

- Shoot at 1/500 or 1/1000 of a second to compensate for the vibration of the helicopter.

- A gyrostabilizer allows you to shoot at slow shutter speeds.

137

CROPPING
REFRAME AN IMAGE

The examples shown illustrate how cropping the print enhances the effect in the final version. There are times when you don't have the most appropriate camera or lens to shoot a particular scene. The image should still be shot, but it may need to be cropped in the printing process.

In commercial work, the designer or art director requires an image that will work effectively. The photograph is going to be cropped and not used full-frame. Instead of the natural boundaries of the frame, the photographer works within the limitations of the design established by the client. Consequently, cropping the photograph is a cut-and-dried decision.

When the photographer approaches his own work, cropping presents a dilemma. Some, myself included, feel that the full frame is a boundary that deserves respect.

Total use of the frame serves as a self-imposed limitation. But I don't see it as a sacred line that, if crossed, devalues an image. The latitude to remove undesired elements from the frame after the shot has been taken can be invaluable.

If cropping is necessary to make the image work, then it should be done. But it shouldn't be used to clean up photographs that are careless in vision and lacking in design. There is a logical midpoint between the purists and the weak designers.

To me, a black border around the print is a visual statement of the complete use of the frame and nothing more. I prefer to crop in the camera and not in the print whenever possible. Today, I see it as a visual statement of sound design for myself, but I do not view it as a requirement to measure the value of the image or my work.

35mm camera, 20mm lens, Ektachrome E100VS

If cropping is necessary to make the image work, then it should be done. But it shouldn't be used to clean up photographs that are careless in vision and lacking in design.

There are times when no matter what you do, you cannot get the full shot that you want. In these cases, cropping is the only solution. This shot for Calton Homes presented problems that could not be solved with the camera. The house sits atop a steep hill. We needed height to eliminate some of the large expanse of foreground grass. Removing a fence and standing on a ladder wasn't enough. These two photographs illustrate how the image looked originally and how it looked for reproduction purposes.

- Cropping removes undesired elements after a shot has been taken.

- In commercial work, cropping is often necessary.

- Do not rely on cropping to fix a badly designed photograph.

COMPUTER RETOUCHING
BROADEN YOUR OPTIONS

The age of the computer has radically altered all aspects of our existence. Your life is constantly affected by rapid changes in technology. Photography is no different in terms of the changes that have occurred over the last decade. This section focuses on retouching and its application in the commercial world.

Today both professionals and amateurs alike use powerful computers, with graphics software such as Adobe Photoshop. In commercial photography, retouching by computer has now become the norm because it is easily done and relatively inexpensive. The photographs used in this section, taken for Design Firms and Advertising Agencies, illustrate how the computer is used today as a means of solving a visual problem.

For the amateur, the computer now offers many opportunities as well. Relatives out of favor can now be deleted. Shots with a gray sky can now have sun and puffy white clouds. Shots of family and friends are routinely scanned and e-mailed all over the world.

While the computer can correct many problems that are unavoidable at the time that an image is shot, like a gray sky, the reality is that many people believe incorrectly that the computer cures and corrects all their mistakes. A badly composed photograph can be salvaged and made somewhat better. Yet it still does not replace a well-designed image. Trees growing out of a family member's head can be moved but why shoot it that way to begin with? Simply, the computer is a tool that is fun to play with. It is really no different than other tools that are available to a photographer, including film type, lens selection, focus, and filtration. However, unlike these tools it is used after the photograph is made. This is one tool that requires a lot of practice, as well as discretion regarding how it is applied.

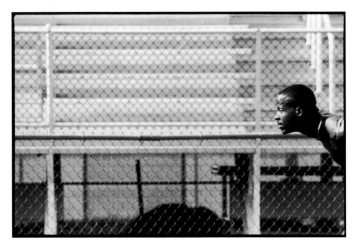
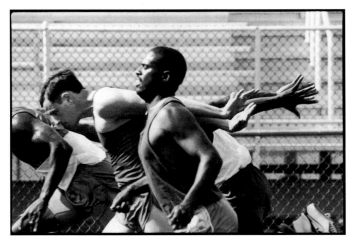

35mm camera, 200mm lens Tri-X Professional

When you shoot commercially, the goal is not only to exceed your client's expectations, but to provide good service, as well. At its best, a commercial shoot is a team effort with good communication between photographer and art director. For four days Creative Director David Sillen and I worked together for 12–14 hours a day on this shoot for a client, Dreyfus. When editing the film for the shoot of the runners lunging toward the finish line, I had numerous choices. But the image that worked the best was a composite of the two photographs shown. David agreed, and he used the computer to delete the black line that separates the two images and then it was cropped to fit the layout.

. . . many people believe incorrectly that the computer cures and corrects all their mistakes.

Winning.

Whether you are vaulting, running, or throwing the javelin, victory may come in inches, or fractions of an inch. At Dreyfus, victory is not complete unless **we all win together.** We measure success by a variety of criteria with **client satisfaction and quality relationships** being top priorities – interrelated and mutually dependent.

Achieving a **sustainable competitive advantage** requires the best resources available. Those most likely to win are those who fully utilize quality resources, augmenting their skills with **expertise, strength, endurance, agility, technology,** and **discipline.**

This is where Dreyfus comes in.

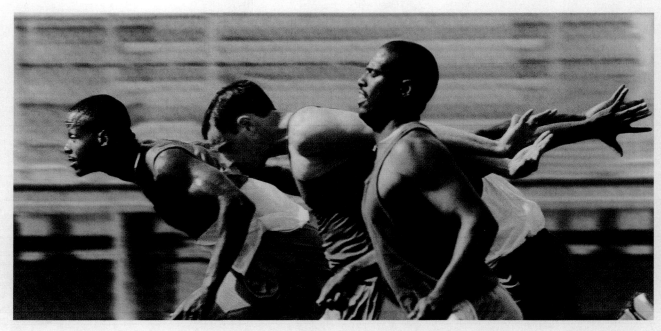

2

- Do not use computers to compensate for a badly designed photograph.

- Practice is required to retouch images effectively.

- Use discretion when retouching photographs.

The three images that follow show the process and use of the integration of photography, illustration, and computer retouching to generate one final image. Creative Director Jeff Yates was creating a collateral piece for a client, Color Wheel, a fine graphics company that specializes in post-production work. Jeff says, "This large format brochure focuses on the technology of putting outdoor advertising on the sides of buildings. To make it unique I selected the beautiful and classic Deco Chrysler building. The company is New York City-based and this building is an icon." I was hired to shoot the building, and following the layout, framed it at an angle. Because it was a cloud-free day, I supplied Jeff with stock photos of the clouds, which were added later. Jeff then gave the photograph to an illustrator who scanned the image and turned it into line art. She used the gargoyle on the building as the model for the illustration. When this was complete, the illustration was placed on the photograph of the building on a special computer called a paint box. The logo for Color Wheel is shown in the grasp of the eagle.

24mm lens, Ektachrome, E100VS

INDEX